American Impressionism

Paintings of Promise

DAVID R. BRIGHAM

WORCESTER ART MUSEUM ■ Worcester, Massachusetts

Pomegranate ■ San Francisco

Published by Pomegranate
Box 6099, Rohnert Park, California 94927

Pomegranate Europe Ltd.
Fullbridge House, Fullbridge
Maldon, Essex CM9 7LE, England

Worcester Art Museum
55 Salisbury Street
Worcester, Massachusetts 01609-3196

The paper used in this publication meets the minimum
requirements of the American National Standard for
Information Sciences—Permanence for Printed Library
Materials, ANSI Z39.48-1984.

ISBN 0-7649-0359-4
Pomegranate Catalog No. A900

Library of Congress Cataloging-in-Publication Data

Brigham, David R.
 American impressionism : paintings of promise /
 David R. Brigham.
 — 1st ed.
 p. cm.
 Catalog of an exhibition held at the Worcester
 Art Museum, Worcester, Mass.
 Includes bibliographical references.
 ISBN 0-7649-0359-4 (pbk. : alk. paper)
 1. Impressionism (Art)—United States—
 Exhibitions. 2. Painting, Modern—19th century—
 United States—Exhibitions. 3. Painting, Modern—
 20th century—United States—Exhibitions.
 I. Worcester Art Museum. II. Title.
 ND210.5.I4B75 1997
 759.13'074744'3—dc21 97-14725
 CIP

Designed by Riba Taylor
Edited by Phil Freshman

Printed in Hong Kong
06 05 04 03 02 01 00 99 98 97 10 9 8 7 6 5 4 3 2 1

First Edition

Contents

Foreword

The Worcester Art Museum's Centennial provides the ideal moment to celebrate an important segment of the institution's encyclopedic collections: paintings and watercolors by American Impressionists. Founded in 1896 and opened in 1898, the Museum immediately embarked on a bold course of displaying contemporary American paintings in annual exhibitions that continued until 1912. These summer shows included important works by such noted Impressionists as Mary Cassatt, Childe Hassam, and John Twachtman, as well as paintings by the likes of George Bellows, Thomas Eakins, Robert Henri, Winslow Homer, and Henry O. Tanner. Prize-winners were selected by prominent artist-jurors, who were themselves acclaimed for their work in a variety of artistic traditions; among them were Barbizon school advocate Henry Ward Ranger, Tonalist John White Alexander, and Impressionists Cecilia Beaux and Edmund Tarbell.

The records from these early shows are made vivid by the lively correspondence between Museum staff members and hundreds of painters, demonstrating remarkable energy and commitment to the new institution's mission. John G. Heywood, who served as manager of the Museum from 1898 to 1907, and Philip Gentner, its first professional director, appointed in 1908, wrote to the artists they wanted to feature, specifying the canvases they most desired for summer exhibitions. Scouts at exhibitions in Boston, New York, Philadelphia, Pittsburgh, and Washington, D.C., helped identify the best accomplishments of the year by both established and emerging artists, and some of these pieces were later selected for the Worcester annuals. Moreover, museums such as the Art Institute of Chicago, the Carnegie Institute, the Corcoran Gallery of Art, and the Pennsylvania Academy of the Fine Arts requested works that had attracted special praise in Worcester for inclusion in their own annual and biennial exhibitions.

The fact that the works in these shows traveled a good deal helped create a healthy balance of cooperation and competition among American museums. This balance is pointedly reflected, for example, in the January 10, 1910, letter that John E. D. Trask, secretary and manager of the Pennsylvania Academy of the Fine Arts, wrote to Philip Gentner requesting the loan of Willard Metcalf's *Prelude,* painted the preceding year (Plate 29): "I think the Metcalf that you

have bought is the only example of his work I have ever seen which I considered as fine as our own 'Twin Birches.'" Gentner gladly consented to the loan, but he could not refrain from adding, "We feel that [*Prelude*] is the best thing Mr. Metcalf has yet done, and that so far it is in a class by itself."

The late-nineteenth- and early-twentieth-century exhibitions of contemporary American art generated considerable local, regional, and national press for the Worcester Art Museum and its sister institutions. Their diligence in searching out fine new achievements by American painters was heralded as a progressive step for the nation's museums and was seen as helping to build a strong foundation for an American art world that would one day thrive. As well, the exhibitions gave healthy boosts to the collections of these museums, many of them recently established. Works that were purchased from the shows—at prices that today seem remarkably modest—

became part of their permanent holdings. The Worcester Art Museum is still proud of the acquisitions made from its early annual exhibitions and is pleased to have the present opportunity to feature these works, alongside loans generously made from a range of private and public collections.

The initial research for this project was supported by The Christian A. Johnson Endeavor Foundation. This catalogue was produced with the help of The Ford Foundation. Finally, Worcester's ability to realize this exhibition was facilitated in large part by Allmerica Financial. The Museum community joins me in expressing gratitude to these institutions for generous contributions in support of *American Impressionism: Paintings of Promise*.

James A. Welu
Director
Worcester Art Museum

Acknowledgments

I am grateful to Holly Trostle Brigham, Elizabeth Johns, and Amy Meyers for their insightful readings of a preliminary draft of my essay for this catalogue and to Phil Freshman for his very thorough and sensitive editing of the manuscript. Their suggestions have improved the clarity and focus of my argument.

While the exhibition *American Impressionism: Paintings of Promise* is mainly composed of oil paintings and watercolors from the collection of the Worcester Art Museum, a number of public institutions and private collectors have generously agreed to lend works that enrich both the exhibition and this book. I especially thank the Cleveland Museum of Art; the Corcoran Gallery of Art, Washington, D.C.; the Indianapolis Museum of Art; the Mitchell Museum at Cedarhurst, Mount Vernon, Illinois; the Museum of Fine Arts, Boston; and a number of private lenders for their willingness to share important paintings from their collections. Kennedy Galleries, New York, helped to locate Childe Hassam's *Columbus Avenue, Boston.* These loans have enabled me to represent the stylistic and cultural concerns of American Impressionist artists more fully.

Recent gifts to the Museum have enhanced this exhibition immeasurably. The Callan family donated Frank W. Benson's beautiful outdoor portrait of Natalie Thayer Hemenway and supplied related photographs that document the artist's 1917 trip with the Thayer and Hemenway families to a Wyoming dude ranch. An anonymous private collector presented the Museum with twenty-five-percent ownership of Edmund Tarbell's *Arrangement in Pink and Gray (Afternoon Tea)*, an exciting addition to the permanent collection. These two paintings are displayed for the first time in the company of the Museum's strong American Impressionist holdings in this exhibition.

Museum Director James A. Welu and Elizabeth de Sabato Swinton, Director of Curatorial Affairs, have supported every facet of my work on this exhibition and catalogue, including my decision to expand the original framework to include loans from other museums. Susan Strickler, my predecessor as curator of American art, had the idea of exhibiting the Museum's American Impressionist paintings as part of the institution's Centennial celebration. She and Melissa Organek Dupree, the Museum's National Endowment for the Arts Intern in American Art from 1993 to 1994, established research files for many of the paintings in this exhibition.

Jill J. Burns, the exhibition's project coordinator, gathered transparencies and photographs and kept production of this catalogue on schedule. She also

provided outstanding research assistance, assembling reviews of exhibitions that were mounted at the Worcester Art Museum and other museums and galleries in the late nineteenth and early twentieth centuries. Finally, she has maintained correspondence with archivists and registrars at institutions where the paintings included in this exhibition debuted. In all of these efforts her work has been exemplary. Margaret A. Avery has ably succeeded Jill in this capacity, carrying forward the organization of contextual photographs for the exhibition and helping to coordinate the efforts of everyone working on the project.

Careful attention paid to the works by paintings conservator Rita Albertson and paper conservator Joan Wright ensured that each object appears in as close to its original state as possible. Albertson and Wright also assisted in confirming dimensions and identifying materials and working methods. Fortunately, many of the Museum's American Impressionist paintings have been in the collection since they were created; consequently, those works have received excellent care from the beginning. Also at the Museum: Kathy Berg and Kathy Gadbois of the library helped check references and gather interlibrary loans; Stephen Briggs did an excellent job photographing paintings for this book; Honee Hess and Marcia

Lagerwey-Commeret helped develop meaningful educational programs tied to the exhibition; Janet Spitz raised funds to support the project; Nancy Swallow coordinated artwork loans with efficiency and good humor; and John Reynolds designed the beautiful installation.

William H. Gerdts very generously opened his remarkable library to me. His many years of research have built files rich with sources on the American Impressionists, including period reviews of all the annual exhibitions of works by The Ten. Most of the newspaper articles cited here about paintings exhibited in those early shows were gleaned from Professor Gerdts's files. He was also helpful in identifying scholars who are now working on catalogues raisonné or monographs focused on individual painters.

I am grateful to the following scholars for sharing their insights and deep knowledge with me: Faith Andrews Bedford and Sheila Dugan on Frank Benson; Nancy Mathews on Mary Cassatt; Ronald Pisano, Robert Bardin, and David Steinberg on William Merritt Chase; Laurene Buckley on Joseph DeCamp and Edmund Tarbell; Kathleen Burnside on Childe Hassam; Bruce Chambers on Willard Metcalf; and Lisa Peters on John Twachtman. James Barter, an independent frame restorer and historian,

shared his expertise about the craftspeople who made frames for many of the works represented here. I appreciate the assistance of William Hosley, the Richard Koopman Curator of American Decorative Arts at the Wadsworth Atheneum, Hartford, Connecticut, in identifying furniture represented in Impressionist interiors. Mark Lynch shared his knowledge of birds with me, which improved my understanding of Frank Benson's paintings.

The staff of the Boston Public Library also advanced my research by directing me to sources in that institution's collections. In particular, the library's individual-artist files contain newspaper and periodical clippings that helped illuminate the ways in which American Impressionism was initially received in the press. Additionally, as a repository for the Archives of American Art, the library opened the door to the Archives' rich store of primary source materials. John Teahan, librarian at the Wadsworth Atheneum, helped me to identify the clipping that I found in Hassam's artist file at the Boston Public Library on that painter's *The New York Window.* The staff at another library, this one at the University of Connecticut, Storrs, aided me in resolving questions about ambiguous references.

Cheryl Leibold, archivist at the Pennsylvania Academy of the Fine Arts, supplied me with entries composed for catalogues that accompanied that institution's annual displays of American paintings. At the Corcoran Gallery of Art, archivist Marisa Keller answered questions about early biennial exhibitions there and about the prizes awarded. Miriam Lowenstamm, Intern for American Arts at the Art Institute of Chicago, similarly contributed information about exhibitions and contemporary critical response to paintings included both in early exhibitions at that museum and in the present show. Jane E. Ward, curator of manuscripts at the Peabody Essex Museum in Salem, Massachusetts, was helpful in granting me access to the Frank W. Benson Papers, a collection that includes many of the artist's letters, diaries, scrapbooks, and photographs. This valuable resource not only helped me understand the artistic and social aspects of Benson's career but also prompted broader questions about the work of his peers.

At Pomegranate, I thank Katie Burke for her care in guiding this book into print; Riba Taylor for her clean layout of the book; and Mary Barbosa for her thoughtful editing suggestions.

To all who contributed so vitally to the form and content of this exhibition and catalogue, I am deeply grateful.

———————————————————

D. R. B.

American Impressionism: Paintings of Promise

DAVID R. BRIGHAM

Light, color, atmosphere, and open brushwork were the rhyme and meter of American Impressionist "poems in pigments."[1] Like the French painters who invented Impressionism, American artists at the turn of the twentieth century created landscapes, figures, and genre paintings that emphasized beautiful glimpses of their subjects under momentary conditions of light and atmosphere. Their palettes ranged from delicate pastels to more vivid hues, which artists applied in thick passages with brushes and palette knives. Light was carefully observed to reflect the season and time of day in which the Impressionists painted, and it served to soften edges and eliminate superfluous details. Bright summer light, perhaps filtered through a tree canopy or an open window, energized their canvases, while gentle morning or winter light offered a more reflective mood. These painters' emphasis on the fleeting moment created images that were at once time-bound and timeless. In short, American Impressionism offered a richly aestheticized view of the world, reflecting what one critic aptly described as "a sense of beauty in the abstract."[2]

Between 1880 and 1920, a period during which the American art world was mainly dominated by Impressionism, the nation was transformed in profound ways. The industrial economy surged, changing everything from the ways most people earned a living to where and how they lived. At one end of the social spectrum, families such as the Carnegies, Rockefellers, and Vanderbilts became famous for their success in harnessing new technologies and complex finances. With the fortunes they amassed, they built lavish homes furnished with artistic treasures and made grand philanthropic gestures by endowing libraries, museums, universities, and other cultural institutions. At the other end of the spectrum, poor workers crowded into badly built, largely unsanitary urban tenements. Cities grew rapidly and became, for the first time, more populated overall than the rural parts of the country. Immigrants flooded into the nation, seeking the promise of a better life. They broadened the range of ethnic, religious, and cultural traditions and formed the backbone of an industrial work force. War was waged in Cuba in 1898, in the Philippines from 1899 to 1902, and in Europe from 1914 to 1918. Labor unions organized, and volatile strikes erupted over unsafe working conditions, low wages, and long hours. Violence scarred the political scene, most notoriously with the assassination of President William McKinley in 1901. Issues of gender, too, were at a point of transformation and contention at the turn of the century. Women vied for better educational, employment, and political opportunities, most visibly in the seven-decade-long drive to gain suffrage that culminated in 1920 with the ratification of the Nineteenth Amendment.

In contrast to the swiftly changing social and political landscape, American Impressionism presented images of stillness, solitude, and optimism. Responding to the 1908 show of works by The Ten, an exhibiting group of the most prominent American Impressionists, one critic beamed, "And thus 'The Ten' deliver their annual message of hope, of life, of promise. Visit the display and fill your soul with color, light and the breeze of promise."[3] In an age of uncertainty and threat, the American Impressionists could be counted on to distract viewers from their worries. In place of the flux of modern life, their canvases offered a "suggestion of the permanent and universal."[4] Critics did not seek social commentary or outrage from the artistic community but instead craved and found "a choice aloofness from the petty disturbances of the world."[5] For another commentator, a vibrant Impressionist canvas shone "like a good deed in a naughty world."[6]

THE IMPORTATION OF IMPRESSIONISM

Impressionism was imported from France to the United States by artists and dealers. Paris had been a magnet for aspiring young painters since the beginning of the nineteenth century. Other European cities—especially London, Dusseldorf, Munich, Venice, Rome, and Florence—continued to attract American painters, but by mid-century Paris was among the most desirable places to cultivate artistic talent. American artists attended French academies and competed to exhibit their work in the Salons, with their participation peaking in the last two decades of the century.[7] Of the artists included in the present exhibition and catalogue, all but William Merritt Chase and Joseph DeCamp studied in the French capital, and even these two eventually traveled there. In the late 1880s and 1890s, the dominant teaching mode in

Paris was still the academic tradition, and a majority of the American Impressionists studied for a time at the Académie Julian under Gustave Boulanger and Jules Lefebvre. They practiced the discipline of drawing from the life model, and they were trained to develop paintings by producing series of preparatory studies. At the same time, they were exposed to the renegade French Impressionist painters, whose canvases of light and atmosphere seemed so fresh and new to some, and were so distasteful to others.

The other method by which Impressionism came to America was through exhibitions intended to capitalize on the nation's growing wealth. The second wave of the Industrial Revolution made the United States an economic power and a storehouse of unprecedented wealth. Important shows appeared in Boston, Chicago, and New York in the 1880s and 1890s and helped create a market and taste for French, and later American, Impressionism. In 1883, for instance, the "Foreign Exhibition" in Boston included French Impressionist paintings sent by the noted dealer Paul Durand-Ruel, who also represented the American Mary Cassatt (1844–1926). In 1886 Durand-Ruel sent approximately three hundred French paintings, including Impressionist and academic pictures, to New York. In 1893 Chicago hosted the landmark World's Columbian Exposition, which included French paintings in the Loan Collection of Foreign Masters. Although these exhibitions often received mixed reviews, they brought major French Impressionist paintings to American soil, helping to cultivate a taste for the new style among collectors and artists.[8] However, artists who are now clearly central to the style did not find immediate institutional approval in the United States. For instance, when the Worcester Art Museum purchased Claude Monet's *Water Lilies* (1908) from Durand-Ruel in Paris in 1910,

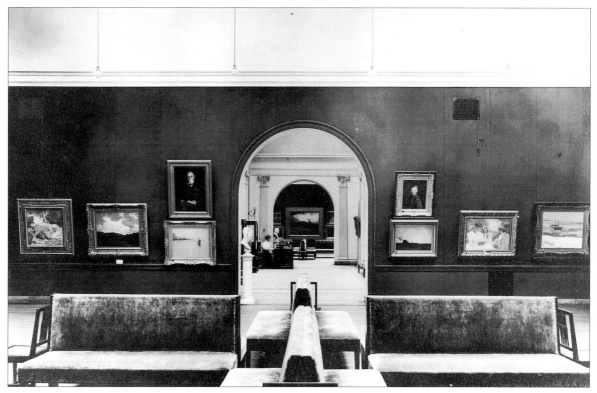

FIGURE I

Worcester Art Museum eleventh annual exhibition, West Gallery, 1908. John Twachtman's *The Waterfall* is the first painting on the left. Frank Benson's *Portrait of My Daughters* is second from the right. Worcester Art Museum Archives.

it was the first museum in the country to purchase a work by this painter.

The availability of art to the general public also increased after the Civil War with the establishment of museums in many American cities. Philanthropic contributions from industrialists, bankers, and other prominent citizens created the Corcoran Gallery of Art (1869), the Metropolitan Museum of Art (1870), the Museum of Fine Arts in Boston (1870), the Art Institute of Chicago (1879), the Carnegie Institute in Pittsburgh (1896), and the Worcester Art Museum (1896). A number of these institutions facilitated the promotion of contemporary trends in American art by mounting annual displays of the latest achievements. Starting with its opening in 1898, for instance, the Worcester Art Museum pre-

sented annual exhibitions. As the contemporary press stated it, "The severest weeding of New York, Boston and Philadelphia galleries has left Worcester nothing but the finest and most notable features of the bigger American galleries."[9] The best paintings were selected each year by a jury of prominent artists, and cash prizes were awarded to the winners. Later the Museum stopped giving prizes, investing the money instead in purchases that helped build collections of contemporary American art, including works by Impressionists. The installation photograph featured here (Figure 1) includes two paintings that were purchased from these early annuals for the permanent collection: John Twachtman's *The Waterfall* (Plate 43) and Frank Benson's *Portrait of My Daughters* (Plate 1).

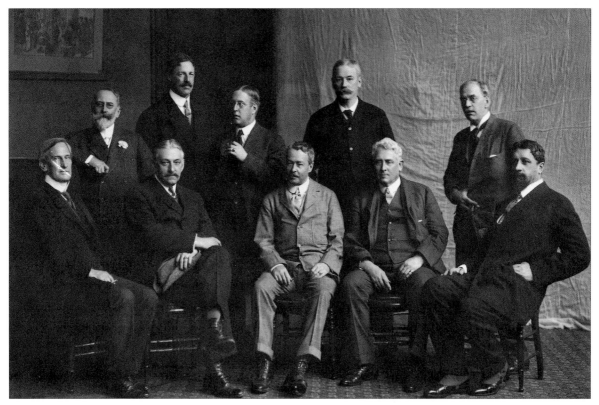

FIGURE 2

Haeseler Photo Studios, Philadelphia. The Ten American Painters, 1908. Standing, from the left: William Merritt Chase, Frank Benson, Edmund Tarbell, Thomas Wilmer Dewing, and Joseph DeCamp. Seated, from the left: Edward Simmons, Willard Metcalf, Childe Hassam, J. Alden Weir, and Robert Reid. Frank W. Benson Papers, Peabody Essex Museum, Salem, Massachusetts.

Artists also established loose associations that helped boost the success of American Impressionism. In 1897 a group of painters resigned from the Society of American Artists so they could mount more intimate annual exhibitions of a consistently high quality. The group, which included Frank Benson (1862–1951), Joseph DeCamp (1858–1923), Childe Hassam (1859–1935), Willard Metcalf (1858–1925), Edmund Tarbell (1862–1938), John Twachtman (1853–1902), J. Alden Weir (1852–1919), and, after Twachtman's death, William Merritt Chase (1849–1916), came to be known as The Ten American Painters—or simply, The Ten (Figure 2). Their early shows in New York were held at Durand-Ruel Galleries, whose director

in Paris sent paintings to the first major exhibition of French Impressionist works in the United States in 1883.[10] Several exhibitions of art by The Ten then traveled to the St. Botolph Club in Boston, a gathering place for artists and writers that was described in 1890 as "the home of the impressionists."[11] Numerous other commercial galleries and art societies lent space to The Ten, and in 1906 their paintings were displayed in Providence, New York, Boston, Detroit, and Chicago.

American Impressionists also participated in artists' colonies, the most famous of which were situated in Cos Cob and Old Lyme, Connecticut, Gloucester, Massachusetts, and on Appledore Island, Maine. Artists and writers gathered,

sometimes in the home of a key personality, to foster each other's talents. In Old Lyme, Florence Griswold, a descendant of a patrician Connecticut family, opened her Georgian mansion to the painters who flocked there each year after 1896.[12] The poet Celia Thaxter, whose father owned Appledore and three other Isles of Shoals, was the galvanizing figure there.[13] Each of these picturesque places was near water, a factor that played an important part in the painters' choices of subject matter. These summer communities also helped to maintain friendships among the Impressionist painters, most of whom had known each other since their student days.

WORKING METHODS

The Impressionists are identified with significant innovations in working method; they cast aside many time-honored painting and drawing traditions. The academic method of preparing careful studies of individual elements and overall compositions gave way to a single direct application of paint, called the alla prima method. What was lost in the meticulous rendering of detail was gained in vitality. Rather than using the studio as the locus of creativity, artists now painted landscapes on-site, a practice known as plein air painting, which helped them capture a more realistic impression of the effects of light and atmosphere on their subjects' form and color. In other words, certain light conditions might make a shadow cast on the grass appear blue rather than dark green. The academic painter would color the shadow dark green, whereas the Impressionist would opt for blue as the truer record. An academic painter might make a careful study of a distinctive tree bark, but the Impressionist would omit that detail if it were not visible from the distance at which the painter happened to be

working. This aspect of Impressionist method only partially accounts for the paintings' appearance. Despite their experiments with alla prima painting, the artists continued to make graphite, pastel, and oil sketches, and they sometimes made preliminary photographs of their subjects. American Impressionists also painted in their studios, including outdoor subjects, even after gaining confidence working à plein air. Still, Impressionist paintings conveyed the sense of momentary effects, whether those effects were contrived in the studio or captured on-site.

The work of Frank Benson demonstrates this duality. Benson was trained in the academic method at the Museum of Fine Arts School in Boston and at the Académie Julian in Paris, an education parallel to that of his peers. Proud of his work outdoors, he had photographs taken of himself on several occasions while working with oil paint and watercolor in natural light. Critics praised him and his fellow artists in this regard, claiming that

the feature that will stand out with strongest emphasis is the artist's new behavior toward nature: his own going out to study it in all its own natural environment of light and his rendering his impressions of it actually in its presence. This, as contrasted with the old idea of making piecemeal notes of nature and then withdrawing with them into the seclusion of the studio to make a more or less arbitrary use of them, will stand out as the essential characteristic of present-day painting.[14]

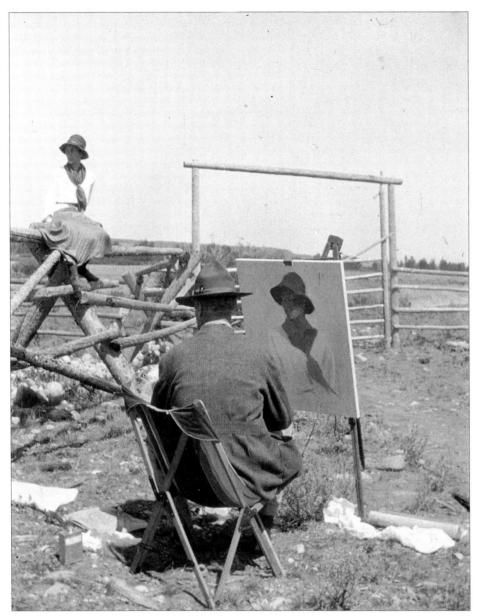

FIGURE 3
Frank Benson painting
Natalie, 1917, at the
Bar-B-C Ranch, Jackson
Hole, Wyoming.
Photograph courtesy
of W. Gordon Means.

Photographs document the outdoor sittings for *Natalie* (Plate 8), showing the artist seated in a folding chair and the sitter perched on a fence rail (Figure 3). However, Benson also painted outdoor subjects in his studio, such as a canvas of geese in flight (Figure 4). While the image of Benson painting *Natalie* gives direct evidence that he worked from life, a photograph of his daughter Eleanor posing for *The Reader* (Figure 5, Plate 5) suggests that he used such images as studies. The

latter photograph also implies that this exquisite rendering of outdoor light was painted, at least in part, indoors.

American Impressionists also sometimes created oil sketches to develop preliminary ideas into complete compositions. Edmund Tarbell's *The Venetian Blind* was first conceived in a very loosely drawn oil study (Plate 40) that captured a partially draped female figure stretched out on a sofa. The finished oil painting (Plate 41) more

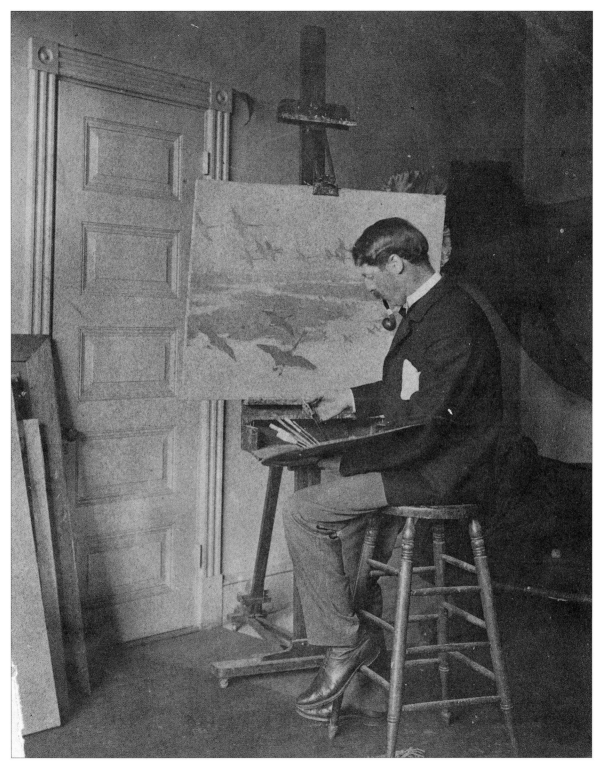

FIGURE 4

Frank Benson in his studio, painting a landscape with geese in flight. Frank W. Benson Papers, Peabody Essex Museum, Salem, Massachusetts.

FIGURE 5
Eleanor Benson posing for *The Reader*, c. 1910. Frank W. Benson
Papers, Peabody Essex Museum, Salem, Massachusetts.

fully elaborates the environment, especially the richly colored and textured light that flows through the Venetian blinds. A vase of flowers to the left, printed drapery, and furniture are all more fully realized in the larger canvas. Tarbell also made compositional changes in the figure, bending the woman's left arm to bring it closer to her body and making the line along the left side of her neck more fluid. Last, Tarbell tucked the woman's right elbow under her head rather than truncating it just below the joint, as it appears in the study. The finished work features broken color and imparts the feeling of momentary effects of light upon animate and inanimate objects, but the study demonstrates the careful planning that preceded this impression.

Childe Hassam's paintings of Boston's Columbus Avenue in the rain demonstrate that an artist's earlier representation of a subject could appear more concrete than a subsequent one. In two such paintings, one made in 1885 (Plate 17) and the other in 1886 (Plate 18), Hassam includes many of the same elements. Two streets intersect, with the main avenue receding along a diagonal from bottom left to center right. Cabs and an omnibus convey passengers through the setting, and pedestrians protect themselves with black umbrellas. Buildings line the far side of the avenue, and a clock tower rises distinctively over the scene on the right. Significantly, the later painting has a more atmospheric quality. The dim evening light and the rain dissolve the forms in the 1886 work, which might be mistaken for a sketch, demonstrating that Hassam was more fully absorbing the Impressionist aesthetic. Both paintings are signed and dated, suggesting that he considered them works in their own right rather than a study and a finished painting.

THE LANDSCAPE AS PLACE OF RESPITE

Although American land was becoming increasingly urbanized and industrialized, especially in the Northeast where the art market was centered, Impressionist landscapes featured natural places of solitude. Rather than embrace the changes occurring around them, the Impressionists preferred scenes that offered an alternative to the clamor of urban life. The places they painted were typically rural and often conveyed a feeling of silence. When the city crept into their paintings, it was often treated as a context for spaces that were set aside for contemplation or leisure.

The American Impressionists lived and worked primarily in two of the nation's busiest cities, Boston and New York. But like many other middle- and upper-class Americans, they made rural retreats during the summer months. Childe Hassam spent many summers from the mid-1880s to 1916 on Appledore Island, one of the Isles of Shoals.[15] On another Maine island, North Haven, Frank Benson and his family purchased Wooster Farm, where they vacationed and Benson painted starting in 1901.[16] His friend Edmund Tarbell bought a home in New Castle, New Hampshire, which offered such comforts as a "wide lawn," "flower beds," a "riverside studio," "a stable of five valuable horses," tennis courts, and a golf course.[17] Among the New Yorkers, William Merritt Chase found quiet in the hills of Shinnecock on Long Island, and John Twachtman removed from the city to a farm in Greenwich, Connecticut.

Typical of the images Childe Hassam created during his summer working vacations, *Sylph's Rock, Appledore* (Plate 22) was painted near a popular resort, yet it depicts an uninhabitable site. Rugged granite boulders catch the light from subtly graded angles, reflecting light back in different colors laid down with horizontal strokes of

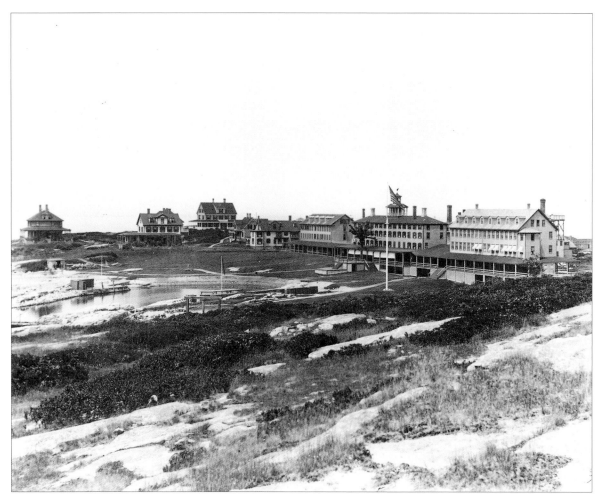

FIGURE 6
Appledore House, Appledore Island, Maine, the resort run by poet
Celia Thaxter's father, Thomas Laighton, and her husband, Levi
Thaxter. Portsmouth Athenaeum, Portsmouth, New Hampshire.

broken color: white, red, blue, and brown. Bright
sunlight and a clear sky help activate the surface
of the rocks, an effect that is complemented by
the movement of the water below. While this
image relies on specific light and atmospheric
conditions to imply transience, the rock forma-
tion itself is immovable. Its immensity and
irregular surface render Sylph's Rock invulnerable
to the taming forces of American industry.
Nearby, however, urban dwellers such as Hassam
clustered together in fashionable company at
Appledore House, where they enjoyed bathing,
sailing, tennis, and each other's society (Figure 6).

They were attracted to the island in part by
advertisements that promised a respite from the
stress of modern middle-class life: "Pre-eminently
the place for the tired worker," one broadside
claimed. "No noise. no dust. no trolleys. A rest
cure in these isles is a thing of joy."[18] If a stay on
Appledore was a welcome withdrawal from the
city, Hassam's painting of Sylph's Rock offered a
further retreat into solitude.

Hassam's example was not the only possible
response to urban life, of course. William Merritt
Chase and Maurice Prendergast (1859–1924)
found vibrant and pleasing scenes of middle-class

leisure in the parks around New York and Boston, just as the French Impressionists were attracted to lively subjects in the public gardens of Paris. A group of park scenes painted by Chase primarily in the late 1880s captures plush spaces that are structured to convey quiet and beauty. His *Early Morning Stroll* (Plate 14), for instance, features a broad area enclosed by winding walls and punctuated by stately piers. The stepped walls and benches invite visitors to sit, while the open space provides a playing field for the well-dressed kneeling child in the foreground. Trees of a variety of shapes, heights, and types shelter the park from its urban environment. Bright sunlight enlivens the peaceful image and activates the whites that connect the figures at left, right, and center. Prendergast also gravitated toward these refreshing preserves from city life. In images such as *Gloucester Park* (Plate 30), Prendergast dotted the scene with figures from one end of the long horizontal composition to the other. Thus his landscape is also a genre scene, populated with groups of women on park benches looking out onto the calm water, a gathering of four men and women conversing on the grass, and a trio of women strolling across the park. A sailboat on the horizon near the center of the image moves gently across the water. The whole scene is painted in simple blocks of mostly unmixed color—green, yellow, blue, orange, and red—set down in mosaiclike patches characteristic of his style. Prendergast's watercolor embraces a basic tenet of mid- and late-nineteenth-century urban planning: As American cities became more densely populated and covered with buildings, parks would have to be established to maintain the presence of nature. This effort was not undertaken to protect nature for environmental reasons but rather to provide city dwellers easy access to the calming and rejuvenating powers of trees, flowers, and bodies of water.

Picturesque blankets of snow offered another antidote to the cares of the era and the intensity of urban activity. In one such image, Ernest Lawson's *Washington Bridge* (Plate 27), a large stone span anchors the composition. Lawson (1873–1939) employs thick dashes of paint, applied with a palette knife, to render natural and built features alike. He interprets the evenness of white snow with his typical rainbow of hues: greens, yellows, blues, and reds. The snow has temporarily restored quiet and natural beauty to the middle of the city. At first glance the scene appears to be completely unpopulated, but on closer inspection two tiny figures may be discerned on the right. The snow envelops the people along with the hill, river, and bridge—all blending into a merry whole.

Snow added quiet beauty to rural landscapes as well, a pictorial device that Willard Metcalf among others exploited. *The White Mantle* (Plate 28), one of a number of paintings he made of farms in winter, exudes peace through the cool unity of snow. In place of the starkness of an all-white composition, he softens the impression with lavender and green tones. Orderly barns and farmhouses offer comfort from the cold and imply an elevated vantage point from which to enjoy the purifying white expanse. For critic Catherine Beach Ely, a contemporary of Metcalf, his landscapes were images of longing, embodying a "mood of homesickness for the haunts we or our parents loved."[19] For another writer of the period, Metcalf's winter landscapes were pleasant scenes full "of delicacy and poetry."[20]

An additional means of presenting the land was to isolate a small segment, as if in a gesture of meditation. In both *The Waterfall* (Plate 43) and *The Rapids, Yellowstone* (Plate 44), John Twachtman features a small section of rushing water in bold strokes of blue, green, and white. *The Waterfall* erases any sense of a particular place by its close

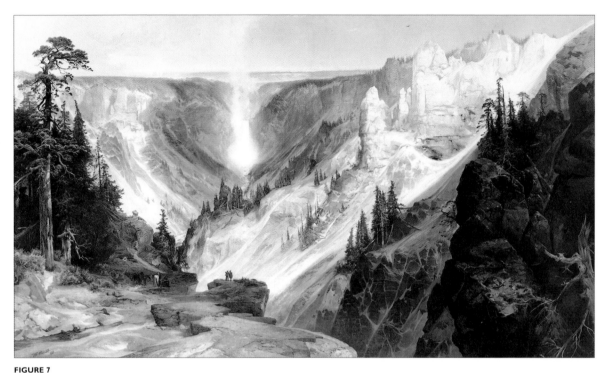

FIGURE 7
Thomas Moran, *The Grand Canyon of the Yellowstone,* 1872, oil on canvas, 7 × 12 ft. National Museum of American Art, Smithsonian Institution, Washington, D.C.

cropping of the subject. While this and related Twachtman paintings represent a site on the artist's farm in Greenwich, Connecticut, the pictures themselves offer no hint of that fact.[21] His continuing interest in this fragment of nature adds to the sense of the meditative function it may have served for him.[22] *The Rapids, Yellowstone* offers a stronger identification of place by its inclusion of two peaks along the horizon. But rather than offering a panoramic, awe-inspiring view of Yellowstone, as Thomas Moran had done a generation earlier (Figure 7), Twachtman chose a viewpoint that mutes the power of the great peaks and directs our attention to the hypnotic swirls of water that were as easily found in his own back-yard. Childe Hassam similarly decontextualized the Isles of Shoals setting for *Looking into Beryl Pool* (Plate 25), emphasizing the absorbing depths of the cobalt blue water instead of the surrounding rocky cliffs.

The exotic landscape exemplified by the oils and watercolors John Singer Sargent (1856–1925) made during his many travels offered escape from the ordinary. In *Shady Paths, Vizcaya* (Plate 37), for instance, he demonstrates his virtuoso skill as a watercolorist, capturing sum-mer light glimmering on neoclassical Italian garden statuary. Trees are broken into a fluttering,

transparent sheet of greens and browns supported by winding trunks made up of ochers and purples. Sargent's choice of subject matter is significant. The site is the Florida estate of the wealthy industrialists Charles and James Deering, whose mansion reminded the artist of a "grand Venetian villa."[23] Similarly, Sargent's watercolor leaves the impression of an Italian garden, and Vizcaya, the Deerings' exotic name for their estate, adds a faraway sense to the title. Sargent's *Oranges at Corfu* (Plate 34) offers yet another Mediterranean fantasy. A balustrade punctuated with two grand vases places the viewer on a luxurious estate. Reinforcing the position of control, the painter establishes a high vantage point over an expanse that encompasses the grove of orange trees stretching to the sea below.

In contrast to the prevalent Impressionist depiction of rural landscapes and hushed urban settings, Childe Hassam also celebrated the thriving streets of Boston and New York. These glimpses of bustling city life are counterbalanced by his paintings of land untouched by human contact. Early in his career Hassam maintained a studio in Boston. As suggested earlier in the descriptions of two of his Columbus Avenue paintings, rainy days provided atmospheric conditions that subdued his palette, while softening the edges of the forms he observed. In an interview conducted several years after he completed *Columbus Avenue, Rainy Day*, Hassam explained his affection for such material. "The street was all paved in asphalt," he said, "and I used to think it very pretty when it was wet and shining, and caught the reflections of passing people and vehicles. I was always interested in the movements of humanity in the street, and I painted my first picture from my window."[24] In the same interview he explained his compositional choice in painting cab drivers from behind, noting: "Their backs are quite as expressive as

their faces. They live so much in their clothes, that they get to be like thin shells, and take on every angle and curve of their tempers as well as their forms."[25] Hassam left Boston in 1886 to study in Paris, and, upon his return in 1889, established himself in New York City. There he continued to celebrate urban life, finding beauty in tree-lined avenues, snow-blanketed streets, and flag-draped buildings. Light, atmosphere, and color provided him with the tools to celebrate the vitality of Manhattan. Aestheticizing the city was a means of participating in modern life while at the same time transforming it into something that transcended the material level.

INTERIOR AS SANCTUARY

If Hassam was willing to venture into the streets, he also sought interior spaces that offered rest from their activity. The New York window pictures, one of his most successful series of canvases, feature solitary female figures in the interior of his Fifty-seventh Street studio.[26] Typically in these works, a woman, either seated or standing, is set off center. Her limbs are held close to her body, and her movements are limited to suggest repose. A bank of long vertical windows behind the figure admits light that is often moderated by gauzy curtains. In contrast to his outdoor urban views, Hassam's window pictures are pervaded by stillness and silence. The city is visible through the windows, manifest in skyscrapers and parks, but its presence is muted.

In *The Table Garden* from 1910 (Plate 23), Hassam relates organic beauty to the constructed forms of city life. The figure stands at right with her back to the viewer, her face turned left to allow a glimpse of her profile. Yet her eyes and expression remain hidden, generalizing her appearance. Her body forms a strong vertical,

which Hassam further stabilizes by resting her left hand on the round table at left. Echoing her upright form are elongated plants in the room and apartment buildings rising outside. Two small rock gardens, in which the plants grow, occupy the center of the tabletop; a third one is hinted at by the green stems at the right. The window frames and curtain folds create still another set of vertical lines, offering a transition between the natural forms inside and the built forms beyond. The woman's gaze leads the viewer to the tall buildings, with columns of windows emphasizing their upward reach.

Hassam also unites interior and exterior with color. The woman's kimono is predominantly blue, a hue that Hassam adds strategically to the windows and roofs of the tall buildings. Similarly, the buildings reflect peach and yellow light, colors the artist uses to highlight the contours of the plants. Touches of yellow also brighten the woman's hair and dress. This unity was clearly intentional and meant to convey meaning. Explaining another window picture containing similar elements, Hassam wrote, "[T]he Chinese lilys [sic] springing up from the bulbs is intended to typefy [sic] and symbolize groth—the groth [sic] of a great city."[27] The buildings themselves suggest rocky cliffs, not unlike the immovable rocks of Appledore. Like the uninhabited places that Hassam found near his favorite busy summer resort, these urban cliffs hide the hundreds of people living behind their glimmering exterior walls.

In 1911 Hassam painted *The Breakfast Room, Winter Morning* (Plate 24), which received rave reviews in the New York show of new works by The Ten and was purchased by the Worcester Art Museum from its fourteenth annual exhibition later that year.[28] Here the format is horizontal rather than vertical. A woman is seated at left, a plate in her lap, peeling an orange. A flower-filled vase and a platter of fruit add bright yellows and oranges to an otherwise cool palette. A span of five windows establishes a steady rhythm across the canvas, varied slightly by the broad post toward the right. Muted light filters through the diaphanous curtains, making the whole surface shimmer in subtle tonal variations. The evenly distributed light obscures details, and although the woman faces the viewer her features are only generally defined. Outside a broad expanse of the city is visible, with one structure towering above the rest. A contemporary critic identified this as the Flatiron Building, which rose 286 feet and was widely acclaimed as a beacon of modern life when it opened in 1902.[29]

As in *The Table Garden*, formal devices relate the woman in *The Breakfast Room, Winter Morning* to her interior and exterior environment. Her seated body creates an isosceles triangle, a shape that lends stability to the composition. Another triangle is implied, joining the woman, the Flatiron Building, and the bowl of fruit. A series of foreshortened circles—the plate, the tabletop, and the fruit platter—link the interior elements. However, the interior-exterior relationship is quite different from the one produced by the spatial dynamics in *The Table Garden*. Whereas the figure's gaze in the earlier painting directs the viewer outside, this woman faces into the room. Psychologically, *The Breakfast Room* interior is more firmly set apart from the city, despite the wide bank of windows. In both paintings, the curtains and light make the forms outside less solid than those inside, a difference that is especially noticeable in *The Breakfast Room*. While the Flatiron Building may have been an assertive feature on the New York skyline, Hassam tames its presence with cool hues and diffused light.

Hassam's major canvas of 1912 was *The New York Window* (Plate 26); it proved to be yet another celebrated achievement, winning the William A.

Clark First Prize and the Corcoran Gold Medal at the Corcoran Biennial, that year entitled *The Fourth Exhibition: Oil Paintings by Contemporary American Artists.* In this work Hassam returned to a vertical format, but several elements from the 1911 composition remained intact: A woman is seated at left, with a bowl of fruit to her right and a group of windows behind her. One contemporary response captures the mood of the painting:

> Twilight has fallen, or it is afternoon of a gray day; through the window shadowy forms of great buildings loom as ghosts against the sky. It is the hour of rest, of meditation, and every line of the figure seated by the window conveys this suggestion.[30]

Indeed, *The New York Window* is considerably more solemn than either of the previous two works, a feeling created in large part by the woman's downward gaze. Her complete inactivity, indicated by her posture and hand placement, accentuates the melancholy air of the image. The treatment of light also adds a somber note. Although the woman's face is in three-quarter view, it is also mainly in shadow, distancing her psychologically. Perhaps Hassam was attempting to suggest that this was a woman keenly affected by the burdens of modern life, a condition then termed hysteria and considered to be an ailment suffered particularly by bourgeois females. According to historian Carroll Smith-Rosenberg, hysteria was normally described as encompassing malaise and depression.[31] Though the figures in all three window paintings examined here rest in solitude, the contemplative hush of this picture may more specifically imply that the woman is convalescing. Even if this was not Hassam's specific intention, the hope and promise so commonly portrayed in American Impressionism appear in this canvas to be a desired, rather than an actual, condition.

JAPAN: A MODEL OF RESTRAINT AND REFINEMENT

The art and culture of Japan came to fascinate the West after that land opened to Western trade in 1854. International exhibitions in Europe and America—London (1862), Paris (1867), Vienna (1873), and Philadelphia (1876)—included substantial representations of Japanese culture.[32] In the ensuing decades Japanese imports entered Western markets, and Eastern motifs and compositional devices were added to the general design vocabulary. Scholarly and popular writing fueled interest in what seemed to be an exotic and mysterious culture.[33] More significantly, according to one major thrust of interpretation, Japan represented a decidedly premodern society.[34] In an age when production was becoming increasingly mechanized, the West perceived Japan as a stronghold of hand craftsmanship. When contrasted with industrialists' ostentatious displays and middle-class domestic clutter, Japanese decoration was seen as a model of restraint.[35]

The turn of the century was a time of longing for stability and order, and for many Japan embodied cultural values that were felt to be sorely lacking in America. Japan's hierarchical social systems stood for productive resignation to one's station in life, as opposed to the kind of social turmoil signaled by growing labor unrest in America.[36] The Haymarket riots in 1886 and the Pullman strike in 1894, both of which unfolded in Chicago, were the most visible demonstrations of growing class tensions. Frustration with American labor was even felt in the furniture industry, and promoters of craft revival held up the example of Japan as "'that land of . . . divine obedience to authority.'"[37]

Japanese culture also was held up as an antidote to American materialism. Beginning in about the 1880s, a burgeoning commercial

culture made its first concerted efforts to promote new desires that could be satisfied through material consumption. In contrast to the measurement of success through possessions, Buddhist teachings promoted "ascetic practices and meditative exercises."[38] Such impressions were shared by Europeans. Art historian Stephen Eisenman has observed, for instance, that for Vincent van Gogh, "Japan was not simply a sign of chicness and exoticism: it was also a dream-image of utopia."[39] Of course, such perceptions had more to do with Western needs than with the real state of Japanese culture.

A deep admiration for Japan was shared by a number of important collectors, whose donations to newly founded American museums created permanent public repositories or displays. Vast collections of Japanese ceramics and prints were amassed by John Chandler Bancroft, William Sturgis Bigelow, Charles Lang Freer, and Denman Ross. Through a deed written in 1906, Freer's collections established the Freer Gallery of Art in Washington, D.C. Bigelow and Ross donated their holdings to the Museum of Fine Arts in Boston, and Bancroft bequeathed more than three thousand woodcuts to the Worcester Art Museum in 1901.[40] Although Japanese culture was used to critique rampant American acquisitiveness and industrialization—in which these men actively participated—an appreciation for the subtleties of Japanese aesthetics was at the same time seen as a sign of refinement.[41] The benefactions of men such as Bancroft and Sturgis constituted important public statements of connoisseurship. Commenting on the significance of these large-scale donations, cultural historian T. J. Jackson Lears wrote, "In their impressive new institutional homes, collections of premodern artifacts became new and striking emblems of upper-class cultural authority."[42]

American Impressionists, like their French counterparts, responded to this trend, adopting both the accoutrements and the design principles of Japanese aesthetics. James Abbott McNeill Whistler (1834–1903), who spent much of his career in London, was among the first American painters to incorporate the lessons of Japanese art into a pre-Impressionist work. His oil sketch for *Rose and Silver: La Princesse du Pays de la Porcelaine* (Plate 47) sets a female figure, holding a fan and clad in a kimono and robe, against a multipaneled screen. Dashes of pink to the woman's left and orange to her right suggest asymmetrical arrangements of flowers, and these colors hint at the Chinese palette of enamelware *en famille rose.*[43] The composition also demonstrates the influence of Japanese prints. One scholar has even suggested that the pose is a direct quotation of the great painter and printmaker Kitagawa Utamaro (1753–1806).[44] Significantly, Whistler painted this image shortly after the International Exhibition of 1862 had introduced an important array of Japanese artifacts to a London audience. The sketch served as a study for a portrait that later formed a key element in Whistler's grandest statement in Japonisme, a fully thought-out and integrated space he called *Harmony in Blue and Gold: The Peacock Room* (1876–77). This room was purchased by Charles Lang Freer in 1904 and is now housed at the Freer Gallery (Figure 8). There, Whistler's finished canvas is part of a larger composition that interweaves porcelain, gilt wall paintings, and elaborate woodwork into an aesthetic whole. Whistler himself was an avid collector of Japanese and Chinese porcelain, and he purchased Japanese costumes in Paris.[45] He regarded porcelain as the highest form of aesthetic achievement and aspired to create paintings of parallel beauty.[46] Thus it is not surprising that he should name the subject of his painting the Princess from the Land of Porcelain.

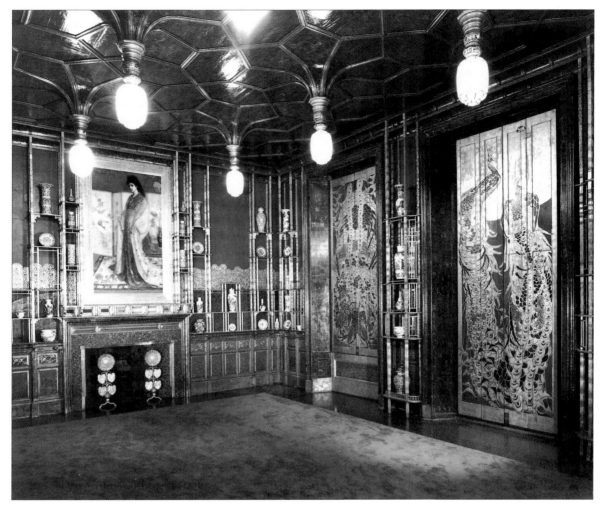

A number of American Impressionists, including Benson, Chase, Hassam, and Tarbell, painted female figures in interiors adorned with Japanese effects. Kimonos, screens, fans, and porcelain added richness of texture and meaning to their subjects. As emblems of premodern life, the kimonos worn by the women in Hassam's *The Table Garden* and *The Breakfast Room, Winter Morning* set the figures apart from their urban surroundings. Chase's *Portrait of Miss Dora Wheeler* (Plate 13) and Tarbell's *Arrangement in Pink and Gray (Afternoon Tea)* (Plate 39) also include Japanese references. Both artists place a principal female figure, with one hand extended to the left and the other raised to her face, near the center of their compositions. Each woman's gaze is directed into the viewer's space, though not necessarily at the viewer, conveying a feeling of confidence and self-possession. The Japanese-inspired textile behind Chase's figure is echoed by the Japanese screen in back of Tarbell's. A rounded ceramic vase to the left of Chase's figure holds flowers, whereas porcelain cups rest on the table in front of Tarbell's subject. This latter detail suggests that the figure in shadow on the left side of Tarbell's painting is there to share tea with the protagonist.

For all these similarities, the impact of the two paintings is quite different. Chase's subject appears to be in the midst of thought, conveying an intelligence to match her physical presence. Tarbell's figure has an aristocratic bearing, with a waiflike body and delicate fingers. She is the sort of woman who might have won praise in the Boston press at a Copley Society tea as one of the season's "noted beauties and great favorites."[47] Both women have a commanding air, which is complemented by their taste in Japanese effects.

By making an afternoon tea the impetus for his painting, Tarbell invoked an important social ritual, imported from the Far East, that helped mark a woman's place in polite society.[48] Tea was sufficiently noteworthy that when the Copley Society mounted its *Fair Women* exhibition of 1902, which included Tarbell's *The Venetian Blind* (Plate 41), the Boston newspapers devoted as much attention to the accompanying society teas as they did to the paintings.[49] Such teas were also commonly noted components of exhibitions held by The Ten in New York City. Similarly, the art colony at Cos Cob, Connecticut, hosted a Japanese visitor named Genjiro Yeto one summer.[50] He is shown in the photograph presiding over a tea ceremony performed by five young American women who demonstrate their authentic knowledge of Japanese culture (Figure 9).

Formally similar to the two Chase and Tarbell paintings, Benson's *Girl Playing Solitaire* (Plate 3) features a beautiful young woman in an interior, with a Japanese screen behind her and a porcelain bowl near at hand. Fashionably dressed, her skirt billowing in forms that echo the clouds on the screen, she passes a quiet moment at cards. Just as prominent as the Japanese features are the pair of silver candlesticks, the early American or colonial revival table, and the Windsor chair, suggestive of the woman's Anglo-Saxon forebears. Significantly, Tarbell's *Arrangement in Pink and Gray* also features a

colonial American gateleg table.[51] Both the Japanese and early American elements in Benson's painting harken to a time or place evocative of the implied simplicity and purity of the sitter. The picture's finishing element is its Arts and Crafts–style frame, carved by the noted Boston firm Foster Brothers, which features clusters of fruit—perhaps a reference to the fecundity of the female subject (Figure 10). The overall effect earned Benson the Norman Wait Harris Silver Medal when the canvas was exhibited at the Art Institute of Chicago in 1909. A *Chicago Tribune* critic praised the painting for its attention to every "last touch of delicacy [and] refinement."[52] In short, American women, colonial craftsmanship, and Japanese aesthetics were all seen as signs of cultural distinction.

Still-life paintings also afforded the opportunity to evoke Asian cultures and the values associated with them. Both J. Alden Weir and Frank Benson painted Impressionist images of table settings that mingled Japanese, Chinese, and American objects. In his *Still Life* (Plate 45), for instance, Weir included what appear to be a Chinese-export covered dish and a blue-and-white Japanese Arita plate. These round forms are echoed by the produce arranged on the table. Weir's asymmetrical composition and bright color accents may also have been employed to suggest a Japanese aesthetic, choices he also made in his landscape paintings in response to his collection of Japanese prints.[53] Benson's *The Silver Screen* (Plate 9) similarly combines objects of diverse origins to create a richly textured middle-class interior. Chinese textiles are draped to reveal an American gateleg table underneath. As Weir did in *Still Life,* Benson includes in this painting a covered jar from China and a multipaneled Japanese screen, along with pieces of fruit chosen for their range of colors and shapes.[54]

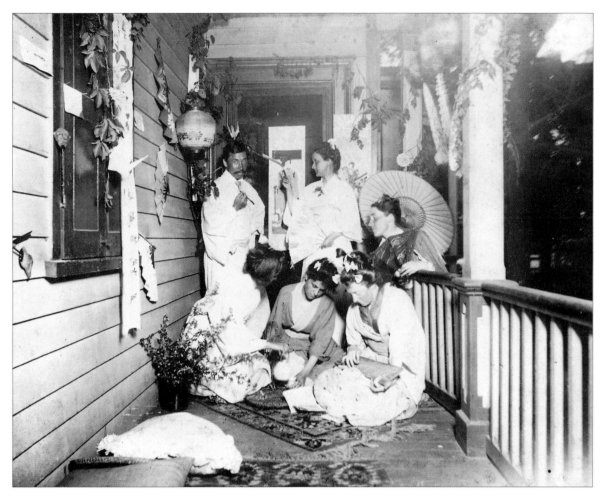

FIGURE 9

Genjiro Yeto leading a tea ceremony on the porch of a house in the
Cos Cob art community. The Historical Society of the Town of
Greenwich, Connecticut.

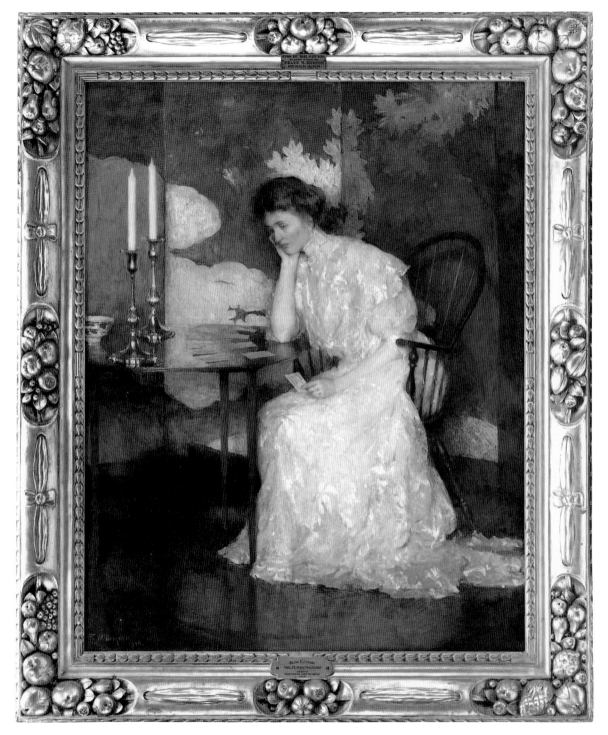

FIGURE 10
Frank W. Benson, *Girl Playing Solitaire*, 1909, oil on canvas,
in a carved gilt frame made by Foster Brothers, Boston.
Worcester Art Museum.

Benson also applied Japanese technical considerations to his paintings. This interest is especially evident in a group of black-watercolor washes, exemplified here by *Eider Ducks Flying* (Plate 6) and *Eider Ducks in Winter* (Plate 7), that suggest the swiftness and economy of Japanese ink painting. One critic, responding to an exhibition of such paintings in 1913, noted:

> The simplicity and directness of rendering of these shelldrakes, coots and terns in the simplest of black and white washes with only the slightest indication of the landscape background have scarcely any parallel outside of Japanese art. The medium, indeed, is handled much as one of the great Ukiyo-ye masters might have used it and the recording of stored observations is not dissimilar in effect. That which one has seen and observed a thousand times one ought to be able to draw.[55]

Benson surely had many opportunities to learn about Japanese culture in the galleries of the Museum of Fine Arts and at such high-style Boston shops as Yamanaka & Co., on Boylston Street. He also surely knew fellow Salem, Massachusetts, native Edward S. Morse, author of the influential book *Japanese Homes and Their Surroundings* and collector of more than five thousand examples of Japanese pottery.[56] In such works as *Eider Ducks Flying,* Benson can be seen blending his interest in Japanese painting with an Impressionist-oriented handling of light and atmosphere—for example, where the wing of the lead bird dissolves in the mist of the wave. His wash paintings of ducks also evoke the masculine realm of hunting, of which he was a lifelong devotee.

WOMEN: IMAGES OF IDEAL AMERICANS

> The type has something of the character of a fine blooded race-horse, long in its lines, clean cut, spare of flesh, the bone and muscle felt beneath it, movement throughout accentuated—unmistakable signs of pedigree. Psychologically also the type is a product of intensive breeding—a cross between the exacting narrowness of Puritanism and the spiritual sensuousness and freedom of Emerson; a transcendentalism of morals and imagination, blended with a little of the questioning and unrest of modern thought. It is, indeed, a new type; strenuous with a sense of inherited responsibilities, but still having a certain air of self-compelling restraint, as if it held itself back a little in view of possibilities scarcely yet realized.[57]

Images of girls and women—in portraits, genre scenes, and the occasional allegory—comprise a major body of American Impressionist paintings. Female subjects carried traditional associations of beauty, but as the above quote suggests they also expressed a wider range of cultural values. The words were those of eminent critic Charles Caffin, writing in 1909 about Frank Benson's murals for the Library of Congress. But Caffin's comments may be more broadly applied to other young women painted by Benson and his peers. Evaluated together, Benson's figures have the appearance of a type partly because he often painted his own children; the familial connection might explain their resemblance. This explanation, however, does not fully account for the values they embodied. As Caffin suggested, they bore "unmistakable signs of pedigree," hinting at an elevated social class and racial purity at a time when a million immigrants from many lands poured into the United States each year.[58] The young women in American Impressionist paintings also epitomized a pleasing

mixture of restraint and freedom. They were eager to explore the possibilities awaiting them but sensible enough to avoid ending in ruin—like characters in the popular melodramatic novels of the day.

The turn of the century was a time of increased promise for women. In 1870 just one in five students in institutions of higher education was female. By 1920 nearly half were women, and most of them were learning in coeducational environments.[59] Women entered the work force in record numbers in this era and participated in the political process to a greater extent than ever before. Through most of the nineteenth century, they were active in social-reform movements, most notably pushing for temperance and against slavery. Starting in 1848, under the leadership of suffragists such as Lucretia Mott and Elizabeth Cady Stanton, women directed their energy toward expanding their own rights. Participation in this movement culminated at the turn of the century and resulted, as earlier noted, in the adoption of the Constitutional amendment extending the vote to women in 1920 (Figure 11).

Images of girls and young women predominate in American Impressionist figure paintings. As cultural historian Martha Banta has argued in her study of popular representations of women, the American Girl was a national symbol of hopefulness.[60] As idealized, she was beautiful, fit, and the perfect embodiment of a relatively new nation ready to burst onto the international stage. Joseph DeCamp's *Sally* (Plate 16) and Benson's *Portrait of My Daughters* (Plate 1), *Dorothy Lincoln* (Plate 2), and *The Reader* (Plate 5) are excellent examples. DeCamp's portrait of his beloved daughter was painted with bravura strokes that energized the subject for contemporary viewers. In the eyes of one critic of the day, DeCamp "mixes vigour in his paint," while for another, *Sally* was "full of robust paint and character."[61]

DeCamp's technique expressed the human qualities he hoped to highlight in his portrait.

Similarly, Benson's compositional choices and style helped express the future prospects of youthful sitters, as in *Dorothy Lincoln*. According to family tradition, Benson was commissioned to paint Lincoln on the occasion of her "coming out"—her formal social debut. She is elegantly attired in a multilayered white dress trimmed in blue ribbon, giving her a buoyant appearance that is tempered by her facial expression. Her crisp posture hints at the fine breeding that Charles Caffin admired in Benson's sitters. The richly verdant natural surroundings suggest that a fertile life lay ahead of her. Tragically, however, Dorothy Lincoln died while on a Grand Tour, not long after her portrait was completed.

Painted in 1917, a decade later, Benson's *Natalie* (Plate 8) conveys a young woman with a greater range of possibilities open to her. In contrast to the decorative gown worn by Dorothy Lincoln, Natalie Thayer wears a simple white shirt and skirt. Her hat is a practical shield from the sun, whose light just touches her nose, chin, and neck and floods her blouse. Her bearing implies a level of independence not evident in the Lincoln portrait. The difference between the two canvases stems in part from the changing roles that women were adopting at the beginning of the twentieth century and in part from the circumstances under which the images were created. Whereas *Dorothy Lincoln* makes a social statement about a newly marriageable woman, *Natalie* portrays a woman dressed to ride a horse.[62] A final difference is that Dorothy sat for her portrait in Benson's Boston studio, while Natalie was painted outdoors during a vacation near the Grand Teton Mountains in Wyoming.[63]

Benson's children were his favorite subjects, and he often painted them outdoors at their summer home in North Haven, Maine. The

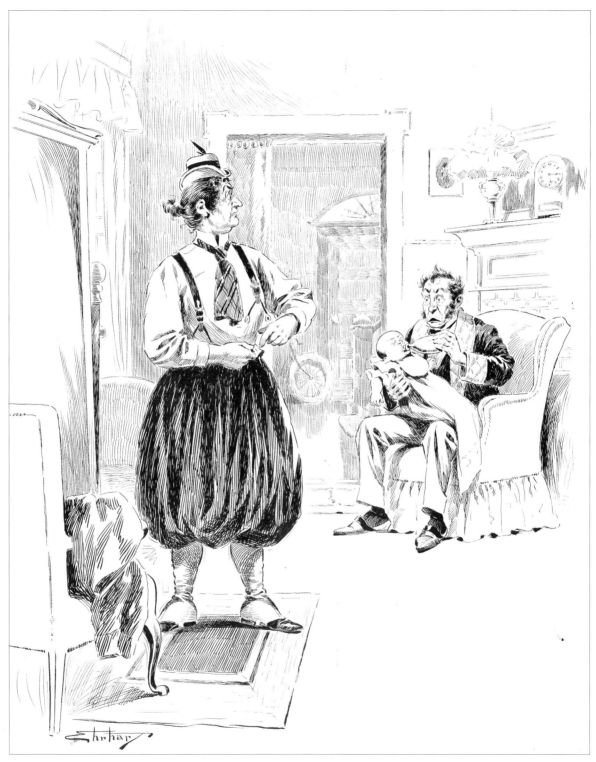

FIGURE 11

Antifeminist cartoons were common responses to women's expanding social roles. Samuel Ehrhardt, *The Emancipated Woman*, 1895, ink drawing in preparation for a cartoon published in *Puck*, February 27, 1895, p. 26. Virginia Steele Scott Gallery, The Huntington Library, Art Collections, and Botanical Gardens, San Marino, California.

bright sunlight allowed him to make his subjects sparkle with light and color. He typically animated the girls' white dresses with long, curling strokes of peach, blue, lavender, and green, as in *Portrait of My Daughters* and *The Reader.* The former picture was among his most celebrated, earning the Temple Gold Medal at the Pennsylvania Academy of the Fine Arts in 1908. Critics lavished praise on the painting for emanating "such an impression of vibrating atmosphere, such a feeling of freedom, joy and wholesome stimulation of vitality."[64] In short, the Impressionist's brushstroke and attention to light and atmosphere were well suited to communicating the desired energy of the American Girl. Eleanor Benson also posed for *The Reader.* Light floods the young woman's hair and falls more gently over her body, as it is filtered by the parasol. Her engagement with the book she is reading is undisturbed. In *The Reader* Eleanor is placed in a garden; perhaps this is a reference to the *hortus conclusus* theme of the solitary Virgin in the enclosed garden. In Christian iconography the enclosed garden signifies Mary's virginity and her invulnerability to Satan's temptations.[65] Whether or not Benson intended so specific a reference in this painting, contemporary viewers perceived his female sitters in general as exemplars of innocence and reserve. One critic noted "the wholesomeness of his art" and applauded "the beauty of girlhood, its grace, its purity, its charm."[66] Another contrasted the "choice reserve" of Benson's female subjects with the "extravagant and conscienceless living" rampant "in our big cities."[67]

American Impressionists also represented women sensually, and nude subjects were not uncommon. Tarbell's *The Venetian Blind* (Plate 41) demonstrates that light and atmosphere could contribute to the tactile richness of a nude. The pose Tarbell selected is modest, and his preparatory oil sketch (Plate 40) demonstrates that he ultimately draped more of the figure than he had

first intended. His choice of title asserted that the painting was a study in particular lighting conditions rather than an expression of female sexuality. Of course, these choices may have been made in deference to the prevailing conservatism of American audiences. Indeed, when the painting was first exhibited in Worcester in 1902, one reviewer noted that "Studies of the nude and semi-nude are in the minority and the lack was not lamented."[68] Largely positive criticism of *The Venetian Blind* focused on the painting as a technical accomplishment. "Here is technical fluency," one critic declared. "Here is nervous force put at the service of a taking pictorial idea."[69] The painter and critic Philip Hale went even further, proclaiming the canvas "the best picture that has been done in America."[70] Less common, though at least as sensual, were American Impressionist images of male nudes. In *The Bathers* (Plate 36), John Singer Sargent uses water to make the flesh glisten and light to set the muscular bodies into beautiful relief. Sargent's poses and the outdoor setting also accord a greater degree of physical freedom to these male subjects than Tarbell allowed the woman in his oil painting.

Images of mother and child, the signature motif of Mary Cassatt's career, celebrated another stage in women's maturity. *In Reine Lefebvre Holding a Nude Baby* (Plate 11), purchased by the Worcester Art Museum from its 1909 annual art exhibition, a young woman holds an infant against her body. Although the sitter was a model about seventeen years old, the closeness of the two figures implies a parent-child relationship.[71] Cassatt was noted for avoiding the sentimentality that was an easy pitfall of this theme. By directing the gazes of the two figures apart, she creates a psychological distance between them, a quality that is in deliberate conflict with their physical unity. Indeed, some critics felt that Cassatt pushed too hard in this direction: "The exclusion of sentimentality

in painting is undoubtedly a negative merit of considerable value," observed one, "but on the other hand one can hardly help feeling that Miss Cassatt is almost brutally indifferent to the 'human interest.'"[72] Cassatt's position as a successful professional made her a model of success for other American women. Critics at the time differed over whether her gender had an impact on her work. While one reviewer suggested that if her paintings were not signed "the critic would probably attribute them to a man," another praised the "qualities of tenderness in her work which could have been put there, perhaps, only by a woman."[73] Cassatt's role as a feminist was more clearly manifest in her submission in 1915 of *Young Woman in Green, Outdoors in the Sun* (Plate 12) and four other works to an exhibition in New York promoting woman suffrage.[74]

Portraits of mature women, such as Benson's *Portrait of a Lady (Edith Perley Kinnicutt)* (Plate 4) and Sargent's *Mrs. Gardiner Greene Hammond (Esther Fiske Hammond)* (Plate 33), emphasized their stature and character. Both women are portrayed as physically attractive, though neither is presented as an ideal beauty. Their dresses, like those of most of the younger women painted by the American Impressionists, are ornamental. Mrs. Kinnicutt wears a lushly painted gauzy gown with beads suspended from a shawl. Mrs. Hammond's costume is accented by a transparent fichu, black ribbon, and a single strand of pearls. As in his portrait of Dorothy Lincoln, Benson sets Edith Kinnicutt outdoors. However, in place of the summer light and verdant setting he used for the younger woman, Benson here employs a golden, autumnal palette to correspond with Kinnicutt's more advanced age. Her upright posture conveys a moral strength that is reinforced by the seriousness of her partly shaded countenance. By contrast, Sargent's half-length portrayal of Esther Fiske Hammond brings her forward in the picture plane,

making her more accessible to the viewer. She has a gentle expression and her head tips slightly toward us, lending her a relatively casual air. Mrs. Hammond plays the young wife and perhaps gracious hostess, while Mrs. Kinnicutt represents a more matronly social position.

The women painted by American Impressionists typically belonged to the upper social classes. Access to wealth clearly dictated who could afford to commission portraits, but genre scenes also usually featured women of the leisure class. They were often presented in interiors, engaged in such productive activities as reading and sewing. Edmund Tarbell also created paintings, such as *Rehearsal in the Studio* (Plate 42), that featured women in small groups performing music. Here a woman stands at left, about to sing from the sheet music in her hand, while a seated man across the room on the right holds a violin. A seated woman rests on the arm of a chair, music held in her relaxed right hand and her head turned toward the floor. Two other seated figures on a sofa in the middle of the composition, their heads in their hands, appear to be bored with the afternoon's cultivating activity. All three seated women allow their bodies to fall from the crisp postures they would be expected to model in public. Pictures seen within the painting, including a Rembrandtesque portrait at left and the Diego Velázquez portrait of Pope Innocent on the back wall, contribute cultural refinement to the environment. Tarbell cleverly reverses the figure in Velázquez's painting, so that the Pope accords the singer the attention that her friends do not. Tarbell's pleasing scene of women developing talents appropriate for young socialites would have been a familiar reflection of Boston life. Sargent's *Venetian Water Carriers* (Plate 31), showing women at physical labor, was a less common American Impressionist image of women and conveyed an undeniably picturesque foreignness.

Work and leisure, city and country, the familiar and the exotic, innovation and tradition—these are some of the social and aesthetic dynamics that enriched American Impressionist paintings. The emergence of an industrial economy transformed the United States in ways that had profound impact on all aspects of life, including art. For the first time, large numbers of middle- and upper-class people lived in urban environments and had unprecedented amounts of leisure time. The significance of that newfound temporal freedom is particularly evident in the picturesque landscapes that the Impressionists chose—the coastlines, woods, parks, and vacation spots; these were the landscapes of escape from the cities that were rapidly becoming the centers of modern life. Leisure is also a key element in the figure paintings of the period, whether the people depicted in them are picking flowers, reading, or taking a break from sipping tea or riding. The style and technique these artists developed in relation to French painting helped convey their message. The bright light and vibrant colors with which they crafted their impressions lend a halcyon quality to the scenes they painted. Even their more melancholic statements, such as Benson's *Girl Playing Solitaire* and Hassam's *The New York Window*, seem to hint at the restorative property of rest. Exhibitions of paintings by the American Impressionists were applauded for their ameliorative effects. Heralding a 1911 show of works by The Ten, one critic wrote that "The room in which the twenty-one canvases are hung is suffused by day with a mellow light and is made restful by the beauties of the art and subtle harmonies of the arrangement."[75] American Impressionist paintings offered a poetic beauty and release from the everyday world, and emerging museums responded by collecting these works for the rejuvenation and enrichment of future generations.

NOTES

1 The expression "poems in pigments" is taken from a newspaper review of an exhibition by The Ten, "In the World of Art," *The World* [New York], April 26, 1903, p. 10. Quoted in William H. Gerdts, "The Ten: A Critical Anthology," in *Ten American Painters,* exh. cat. (New York: Spanierman Gallery, 1990), 24. Although the critic was referring specifically to the paintings of John Twachtman, many similar observations were written about works by other American Impressionists.

2 Charles H. Caffin, "The Art of Edmund C. Tarbell," *Harper's Monthly Magazine* 117, no. 697 (June 1908): 66.

3 James B. Townsend, "Annual Exhibition of the Ten," *American Art News* 6, no. 23 (March 21, 1908): 4.

4 Caffin, "The Art of Edmund C. Tarbell": 74.

5 Ibid.

6 William H. Downes, "The Spontaneous Gaiety of Frank W. Benson's Work," *Arts and Decoration* 1, no. 5 (March 1911): 196.

7 Lois Marie Fink, *American Art at the Nineteenth-Century Paris Salons* (Washington, D.C.: National Museum of American Art, Smithsonian Institution; Cambridge, England: Cambridge University Press, 1990), 136, 313–409.

8 Hans Huth, "Impressionism Comes to America," *Gazette des Beaux-Arts* ser. 6, vol. 29 (April 1946): 225–52.

9 "Private View at Art Museum: Summer Exhibit of Oils Seen by 200 Ticket Holders," *Worcester Daily Telegram,* May 30, 1902, p. 5.

10 William H. Gerdts, "The Ten: A Critical Chronology," in *Ten American Painters,* 11–13; and Carol Lowrey, "Index to the Exhibitions of the Ten," in ibid., 177.

11 From the *Boston Advertiser,* 1890. Quoted in Doris A. Birmingham, "Boston's St. Botolph Club: Home of the Impressionists," *Archives of American Art Journal* 31, no. 3 (1991): 26.

12 Jeffrey W. Andersen, "The Art Colony at Old Lyme," in Harold Spencer et al, *Connecticut and American Impressionism,* exh. cat. (Storrs: William Benton Museum of Art, University of Connecticut, 1980), 116–17.

13 David Park Curry, *Childe Hassam: An Island Garden Revisited,* exh. cat. (New York and London: Denver Art Museum in association with W. W. Norton, 1990), 21.

14 Charles H. Caffin, "The Art of Frank W. Benson," *Harper's Monthly Magazine* 119, no. 709 (June 1909): 111–12. It should be noted that there were American Impressionists who did not work from preparatory studies. For instance, Lisa N. Peters, director of research for the John Henry Twachtman catalogue raisonné, notes that "Throughout his career, Twachtman did not create drawings or studies for his work. His practice was to work directly" (letter to the author, October 8, 1996). Bruce W. Chambers, director of the Willard Metcalf catalogue raisonné, indicates that this was Metcalf's method as well (conversation with the author).

15 Curry, *Childe Hassam,* 14, 33.

16 John Wilmerding, "Benson and Maine" and Sheila Dugan, "Frank Benson: Outdoors," in Ira Spanierman et al, *Frank W. Benson: The Impressionist Years,* exh. cat. (New York: Spanierman Gallery, 1988), 11–27.

17 "W. H. D." [probably William Howe Downes], "The Fine Arts: Tarbell at Home," *Boston Evening Transcript,* July 17, 1914, p. 7. Clipping in Tarbell's artist file, Boston Public Library.

18 Cited in Curry, *Childe Hassam,* 22.

19 Catherine Beach Ely, "Willard L. Metcalf," *Art in America* 13, no. 6 (October 1925): 336.

20 "Art and Artists," *The Globe and Commercial Advertiser* [New York], March 19, 1909, p. 6.

21 Harold Spencer, "Reflections on Impressionism, Its Genesis and American Phase," in Spencer et al., *Connecticut and American Impressionism,* 51.

22 Other similar Twachtman works include: *The Waterfall,* 1890s, oil on canvas, Hirshhorn Museum and Sculpture Garden, Smithsonian Institution, Washington, D. C.; *Waterfall,* 1890s, oil on canvas, Metropolitan Museum of Art; *The Waterfall, Blue Brook,* c. 1899, oil on canvas, Cincinnati Art Museum; and *The Cascade,* late 1890s, oil on canvas, private collection.

23 John Singer Sargent to Thomas Fox, April 10, 1917, from Brickell Point, Miami. Letter in Boston Athenaeum. Quoted in Trevor J. Fairbrother, catalogue entry in Susan E. Strickler et al., *American Traditions in Watercolor: The Worcester Art Museum Collection,* exh. cat. (New York: Abbeville Press for the Worcester Art Museum, 1987), 132.

24 A. E. Ives, "Talks with Artists: Mr. Childe Hassam on Painting Street Scenes," *Art Amateur* 27, no. 5 (October 1892): 117.

25 Ibid.: 116.

26 For another discussion of this series, see Ulrich W. Hiesinger, *Childe Hassam: American Impressionist,* exh. cat. (Munich and New York: Prestel-Verlag, 1994), 145–48.

27 Childe Hassam to John W. Beatty, March 8, 1920. Quoted in Gail Stavitsky, "Childe Hassam and the Carnegie Institute: A Correspondence," *Archives of American Art Journal* 22, no. 3 (1982): 6. Hassam was writing about his painting *Tanagra,* 1918, oil on canvas, National Museum of American Art, Smithsonian Institution, Washington, D.C.

28 See, for instance, J. Nilsen Laurvik, "The Fine Arts. The Ten American Painters," *Boston Evening Transcript*, March 23, 1911, p. 3; "Art at Home and Abroad. Fourteenth Annual Exhibition of the Ten American Painters at the Montross Galleries," *The New York Times*, March 26, 1911, magazine section, part 5, p. 15; and R. W. Macbeth, "Secessionists Exhibit in New York. 'The Ten' and 'The Twelve' Showing Pictures of Varying Degrees of Interest—Some Present American Tendencies," *Christian Science Monitor*, April 1, 1911, p. 15. On the purchase, see Childe Hassam to Philip Gentner, June 27, 1911; September 1, 1911; and October 17, 1911. Letters in Worcester Art Museum curatorial files.

29 "Nine of the Band Exhibit at the Montross Galleries," *The Evening Post* [New York], March 20, 1911, p. 9.

30 Untitled notice of Hassam's *The New York Window*, in *Art and Progress* 4, no. 4 (February 1913), unnumbered preliminary page.

31 Carroll Smith-Rosenberg, "The Hysterical Woman: Sex Roles and Conflict in Nineteenth-Century America," in *Disorderly Conduct: Visions of Gender in Victorian America* (New York and Oxford, England: Oxford University Press, 1985), 197–216.

32 William Hosley, *The Japan Idea: Art and Life in Victorian America*, exh. cat. (Hartford, Conn.: Wadsworth Atheneum, 1990), 30, 32.

33 Ibid., 45–46.

34 Hosley describes the American perception of "a living medieval culture" in *The Japan Idea*, 49.

35 Ibid., 31.

36 T. J. Jackson Lears, *No Place of Grace: Antimodernism and the Transformation of American Culture, 1880–1920* (New York: Pantheon, 1981), 85.

37 Ibid., 85.

38 Ibid., 229.

39 Stephen F. Eisenman et al., *Nineteenth Century Art: A Critical History* (London and New York: Thames and Hudson, 1994), 296.

40 Lears, *No Place of Grace*, 186, 188; Susan E. Strickler, "Building a Collection," in *Worcester Art Museum: Selected Works* (Worcester, Mass.: Worcester Art Museum, 1994), 8; and Elizabeth de Sabato Swinton, "John Chandler Bancroft: Portrait of a Collector," *Worcester Art Museum Journal* 6 (1982–83): 53–63.

41 Freer made a fortune in railroads (Lears, *No Place of Grace*, 190); Ross was a Harvard design professor (idem, 94); Bigelow, a member of a prominent Boston family, was trained in medicine (idem, 226–27); and Bancroft was the son of the noted historian George Bancroft (Swinton, "John Chandler Bancroft": 53).

42 Lears, *No Place of Grace*, 188.

43 Linda Merrill, "Whistler and the 'Lange Lijzen,'" *The Burlington Magazine* 136, no. 1099 (October 1994): 688.

44 Basil Gray, "'Japonisme' and Whistler," *The Burlington Magazine* 107, no. 747 (June 1965): 324.

45 Merrill, "Whistler and the 'Lange Lijzen,'": 683, 688.

46 Ibid.: 683. Merrill sees this painting as a key step in "Whistler's ambition to reform his art in the image of porcelain—to live up, as it were, to his own blue china."

47 "Second Tea for 'Fair Women,'" *The Boston Post*, March 7, 1902, p. 3.

48 The periodical *International Studio* reminded its readers of the connection between tea and its Eastern origins, while reporting on an "instance of Japanese interior decoration applied to American uses," for example, in "The Japanese Tea-Room of the Auditorium Annex, Chicago," *International Studio* 33, no. 129 (November 1907): xxxiv–xxxviii.

49 "Second Tea for 'Fair Women,'" p. 3; and "Society at Tea for Fair Women," *The Boston Post*, March 11, 1902, p. 5.

50 Yeto is identified in a letter from Susan Richardson, archivist of the Historical Society of the Town of Greenwich, Connecticut, to Jill J. Burns, Worcester Art Museum, November 18, 1996.

51 Trevor Fairbrother identifies this table as one of Tarbell's possessions in "Edmund C. Tarbell's Paintings of Interiors," *The Magazine Antiques* 131, no. 1 (January 1987): 232–33.

52 *Chicago Tribune*, November 21, 1909. Clipping in the Art Institute of Chicago.

53 For Weir's interest in Japanese art, see Doreen Bolger Burke, *J. Alden Weir: An American Impressionist* (Newark: University of Delaware Press; New York, London, and Toronto: Cornwall Books, 1983), 202–16.

54 I thank Elizabeth de Sabato Swinton for sharing her expertise in identifying the possible origins of the still-life objects depicted by J. Alden Weir and Frank W. Benson in the paintings discussed here.

55 F. W. Coburn, "Mr. Benson's Birds," *The Boston Herald*, November 16, 1913, p. 28.

56 Hosley, *The Japan Idea*, 30–31.

57 Caffin, "The Art of Frank W. Benson": 106.

58 John M. Murrin et al., *Liberty, Equality, Power: A History of the American People* (Fort Worth, Tex.: Harcourt Brace College Publishers, 1996), 638.

59 Mabel Newcomer, *A Century of Higher Education for American Women* (New York: Harper and Row, 1959), cited in ibid., 663.

60 Martha Banta, *Imaging American Women: Idea and Ideals in Cultural History* (New York: Columbia University Press, 1987), 45–91.

61 David Lloyd, "The Exhibition of the Ten American Painters," *International Studio* 31, no. 123 (May 1907): xciv; and "Ten American Painters," *New York Sun*, March 22, 1907, p. 8.

62 Natalie Thayer Hemenway, *Mostly Horses by Me* (privately printed, no date), documents her love of horses and recalls her trip to Wyoming.

63 Dorothy Lincoln's sitting is documented in a diary that remains in the possession of her family. Natalie Thayer's sitting is recorded in a letter from Benson to his daughter Eleanor, August 24, [1917,] in the Frank W. Benson papers, Peabody Essex Museum: "While mother was away I was terribly homesick but Dr. Woodward came along & ordered a portrait of his little girl (out of doors) & I began then to enjoy everything better. Then Polly asked me to paint a head of Natalie the day they got back & now I'm glad to get an hour to ride or go fishing."

64 "The Fine Arts. Mr. Benson's Prize Picture," *Boston Evening Transcript*, April 9, 1908, p. 11.

65 Gertrud Schiller, *Iconography of Christian Art*, 2 vols., trans. Janet Seligman (Greenwich, Conn.: New York Graphic Society, 1971), vol. I, 53.

66 "The Fine Arts. Recent Paintings by Mr. Benson," *Boston Evening Transcript*, October 1, 1908, p. 9.

67 Caffin, "The Art of Frank W. Benson": 107.

68 "Private View at Art Museum," p. 5.

69 "Art Exhibitions. The Ten American Painters," *New York Tribune*, March 21, 1901, p. 6.

70 Hale quoted in Caffin, "The Art of Edmund C. Tarbell": 72.

71 Natalie Spassky et al., *A Catalogue of Works by Artists Born between 1816 and 1845*, vol. 2 of *American Paintings in the Metropolitan Museum of Art* (New York: Metropolitan Museum of Art in association with Princeton University Press, 1980–94), 648.

72 "The Fine Arts. Miss Mary Cassatt's Exhibition," *Boston Evening Transcript*, February 9, 1909, p. 11.

73 "As to Women in Art," unidentified clipping, April 21, 1924, in Cassatt's artist file, Boston Public Library; and "Mary Cassatt: New Light on 'A Painter of Children and Mothers' in a Book Just Published in France," *Boston Evening Transcript*, January 22, 1914, p. 11. This is an unsigned book review; the quote is from a book by the critic Royal Cortissoz.

74 Nancy Mowll Mathews, *Mary Cassatt* (New York: Harry N. Abrams in association with the National Museum of American Art, Smithsonian Institution, 1987), 149.

75 "Ten Painters Hold Annual Exhibition," *New York Herald*, March 18, 1911, p. 9.

Color Plates

Except where noted, works are in the collection of the Worcester Art Museum. In dimensions, height precedes width.

The watercolors illustrated in Plates 6, 35, and 36 are on view October 5–November 16, 1997; those in Plates 7, 37, and 38, November 17, 1997–January 4, 1998.

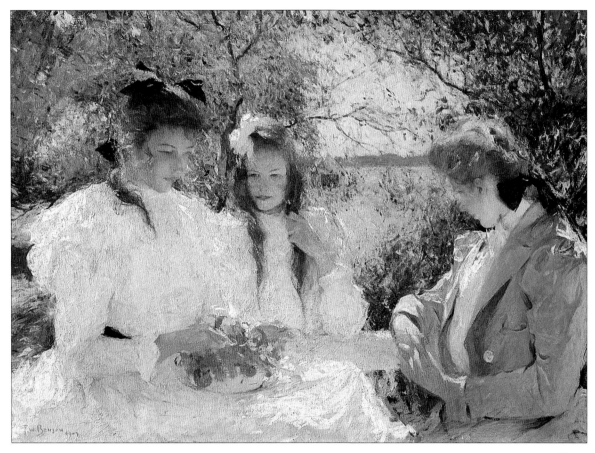

Plate I

Frank W. Benson (1862-1951)

Portrait of My Daughters, 1907
Oil on canvas
26 x 36⅛ in. (66 x 91.7 cm)
Museum purchase, 1908.4

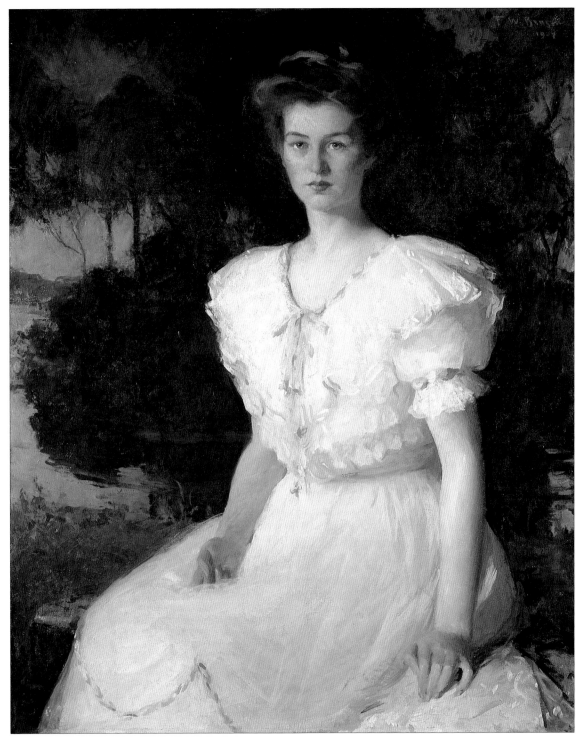

Plate 2

Frank W. Benson

Dorothy Lincoln, 1907
Oil on canvas
44 x 36 in. (111.8 x 91.7 cm)
Private collection

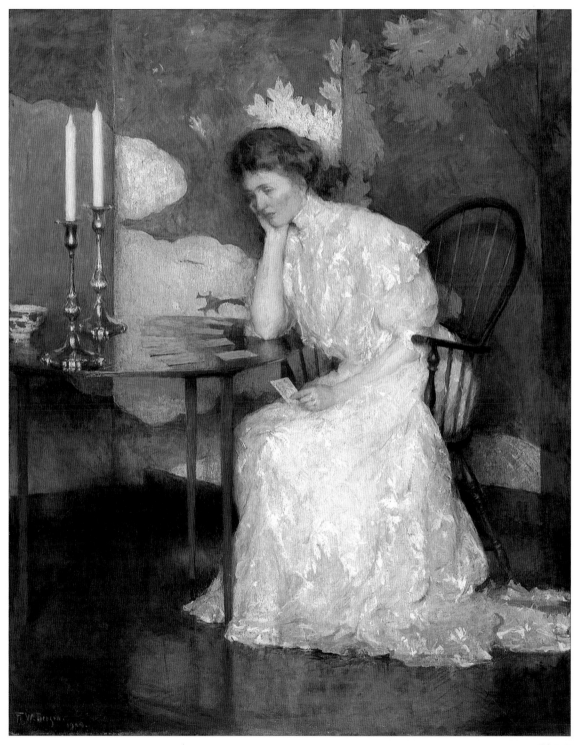

Plate 3

Frank W. Benson

Girl Playing Solitaire, 1909
Oil on canvas
50½ x 40½ in. (128.3 x 102.9 cm)
Museum purchase, 1909.14

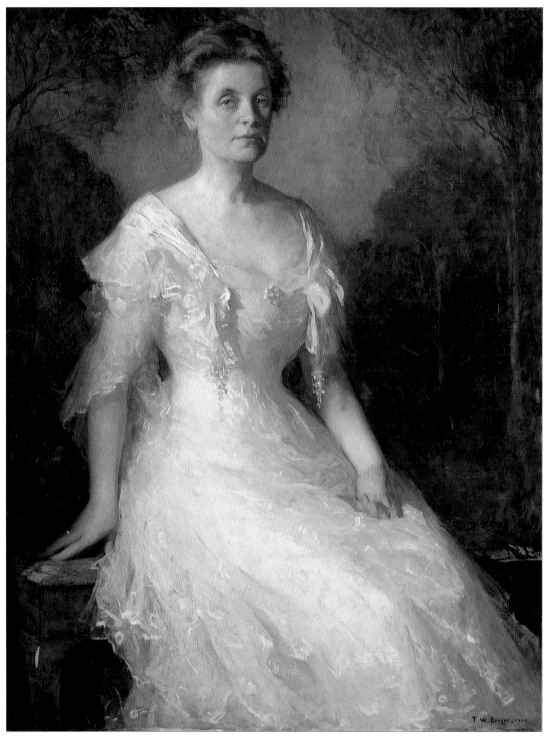

Plate 4

Frank W. Benson

Portrait of a Lady (Edith Perley Kinnicutt), 1909
Oil on canvas
50 x 40⅛ in. (127 x 102 cm)
Gift of Mrs. Edith Kinnicutt Pierpont, 1980.137

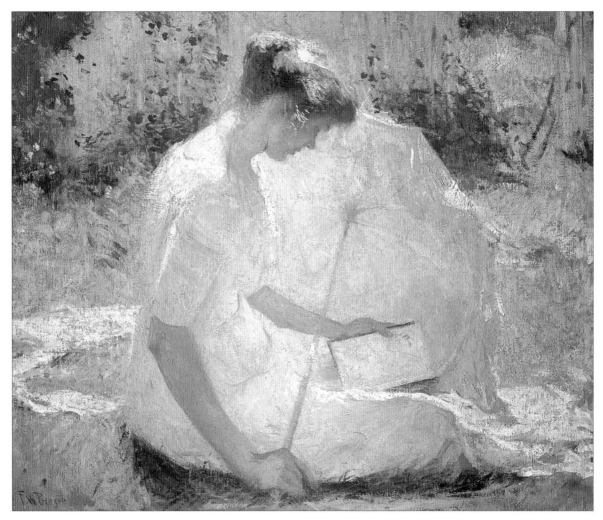

Plate 5

Frank W. Benson

The Reader, 1910
Oil on canvas
25¼ x 30¼ in. (64.1 x 76.8 cm)
Private collection

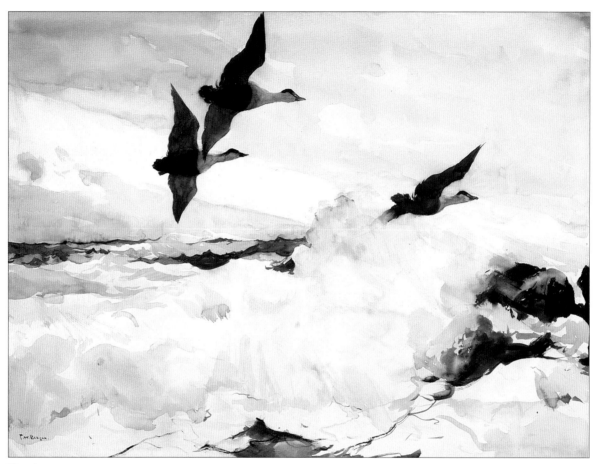

Plate 6

Frank W. Benson

Eider Ducks Flying, c. 1913
Watercolor over graphite on off-white
 textured wove paper
20 x 27 in. (50.6 x 68.5 cm)
Museum purchase, 1913.60

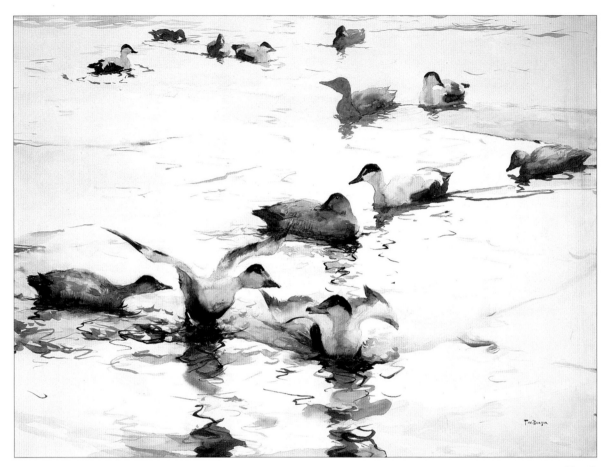

Plate 7

Frank W. Benson

Eider Ducks in Winter, c. 1913
Watercolor, gouache, and lead white additions over
 graphite on off-white wove paper
19¾ x 26¾ in. (50.1 x 67.9 cm)
Museum purchase, 1913.61

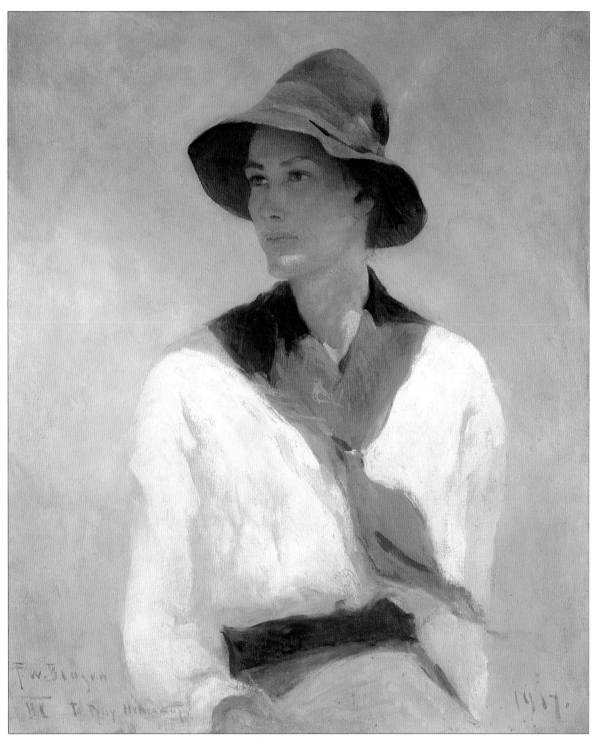

Plate 8

Frank W. Benson

Natalie, 1917
Oil on canvas
30 x 25 in. (76.2 x 63.5 cm)
Gift of Desmond Callan, Mary H. Bailey,
and Cristina E. Callan, 1996.106

Plate 9

Frank W. Benson

The Silver Screen, 1921
Oil on canvas
36¼ x 44 in. (92 x 111.8 cm)
Museum of Fine Arts, Boston. Abraham
 Shuman Collection, 1979.615

Plate 10

Mary Cassatt (1844–1926)

Sketch of *Master St. Pierre*, c. 1892
Pastel on paper
22 x 18 in. (56 x 46 cm)
Private collection

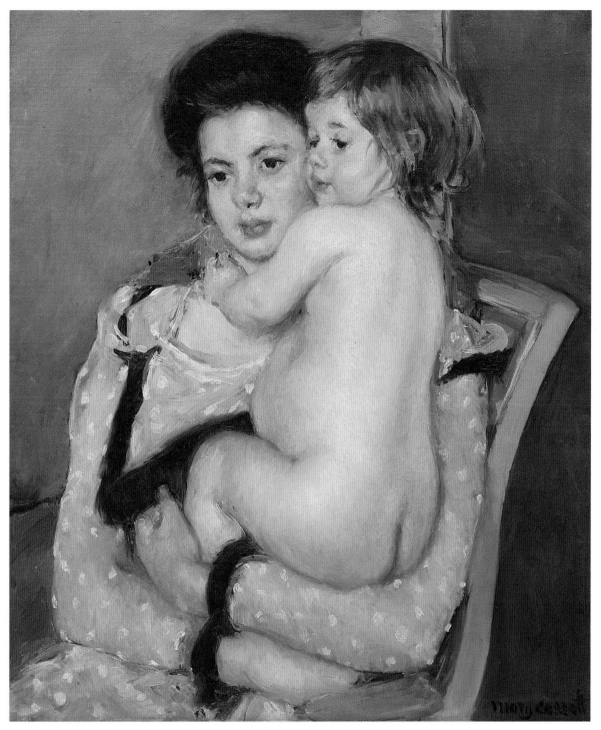

Plate 11

Mary Cassatt

Reine Lefebvre Holding a Nude Baby, 1902–03
Oil on canvas
26¹³⁄₁₆ x 22⁹⁄₁₆ in. (68.1 x 57.3 cm)
Museum purchase, 1909.15

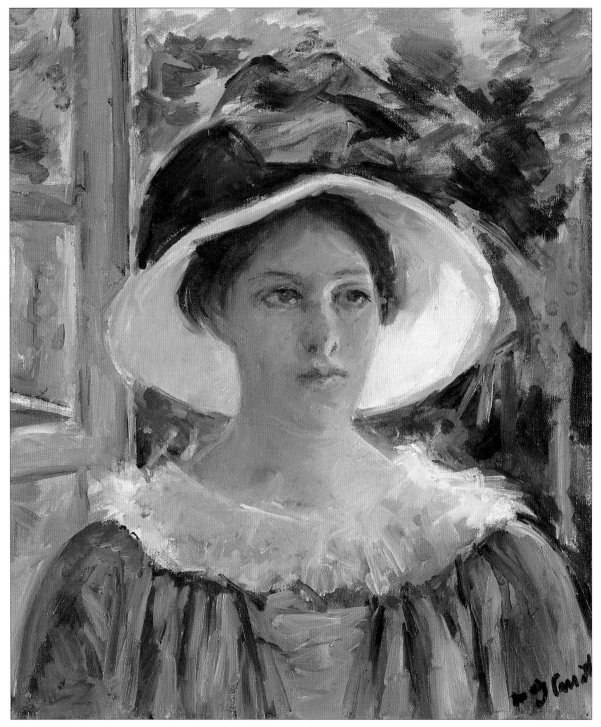

Plate 12

Mary Cassatt

Mary Cassatt

Young Woman in Green, Outdoors in the Sun, c. 1914
Oil on canvas
21⅝ x 18⅛ in. (55 x 46 cm)
Gift of Ernest G. Stillman, 1922.12

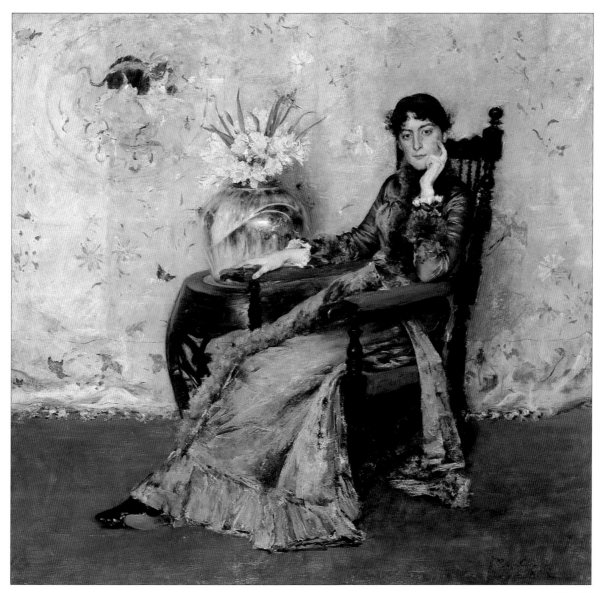

Plate 13

William Merritt Chase (1849-1916)

Portrait of Miss Dora Wheeler, 1883
Oil on canvas
62½ x 65¼ in. (158.7 x 164.7 cm)
Cleveland Museum of Art
Gift of Mrs. Boudinot Keith in memory
 of Mrs. J. H. Wade

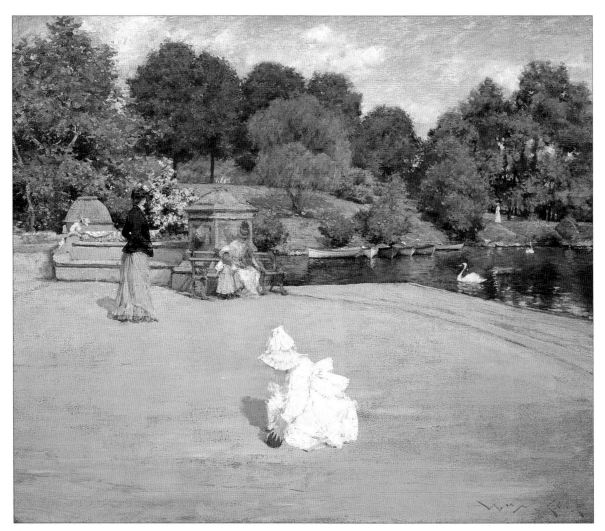

Plate 14

William Merritt Chase

Early Morning Stroll, 1887–91
Oil on canvas
20¾ x 24½ in. (52.7 x 62.2 cm)
Private collection

Plate 15

William Merritt Chase

Portrait of Mrs. William Clark
Oil on canvas
23⅞ x 17 in. (60.8 x 43.3 cm)
Sarah C. Garver Fund, 1973.7

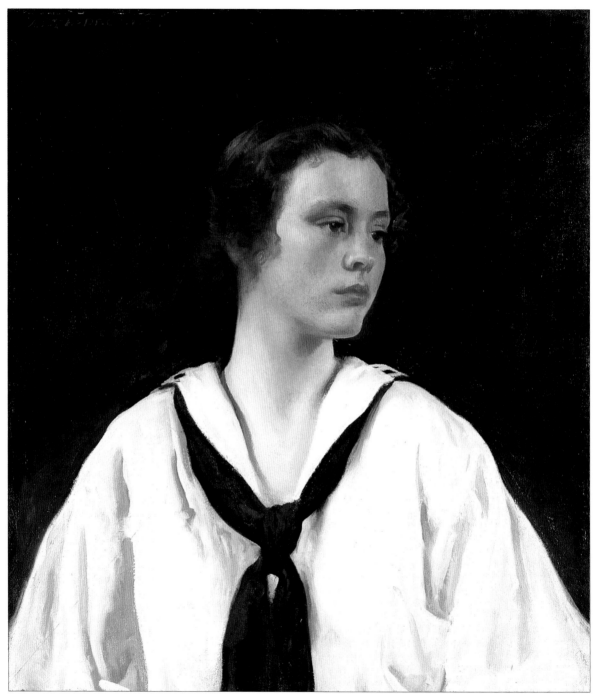

Plate 16

Joseph DeCamp (1858–1923)

Sally, c. 1907
Oil on canvas
26 x 23 in. (66 x 58.4 cm)
Museum purchase, 1908.21

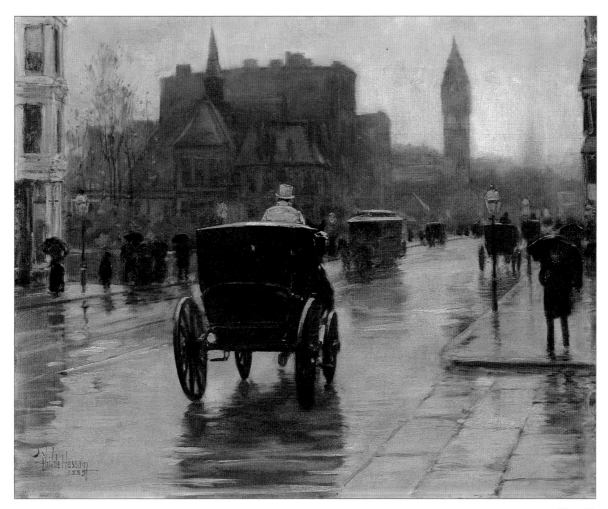

Plate 17

Childe Hassam (1859–1935)

Columbus Avenue, Rainy Day, 1885
Oil on canvas
17⅛ x 21⅛ in. (43.5 x 53.7 cm)
Bequest of Charlotte E. W. Buffington, 1935.36

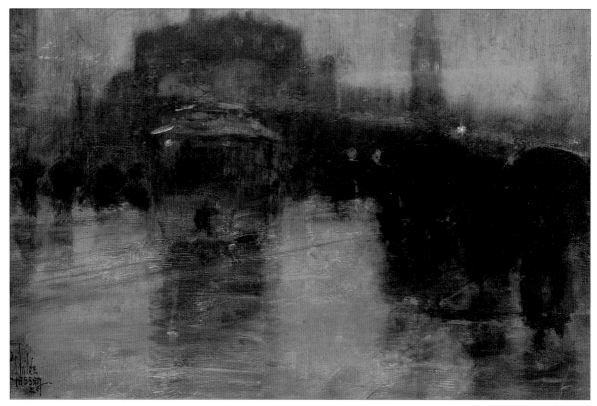

Plate 18

Childe Hassam

Columbus Avenue, Boston, 1886
Oil on wood panel
7½ x 11¼ in. (19.1 x 28.6 cm)
Private collection

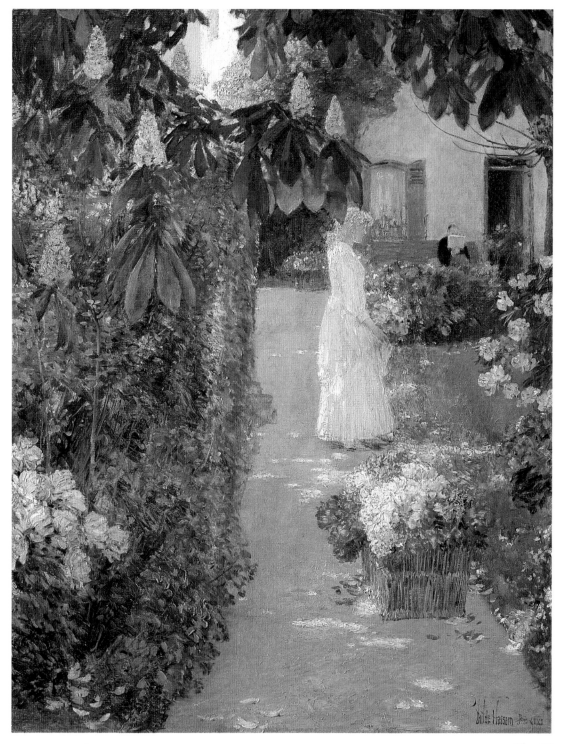

Plate 19

Childe Hassam (1859–1935)

Gathering Flowers in a French Garden, 1888
Oil on canvas
28 x 21⅝ in. (71.1 x 55.1 cm)
Theodore T. and Mary G. Ellis Collection, 1940.87

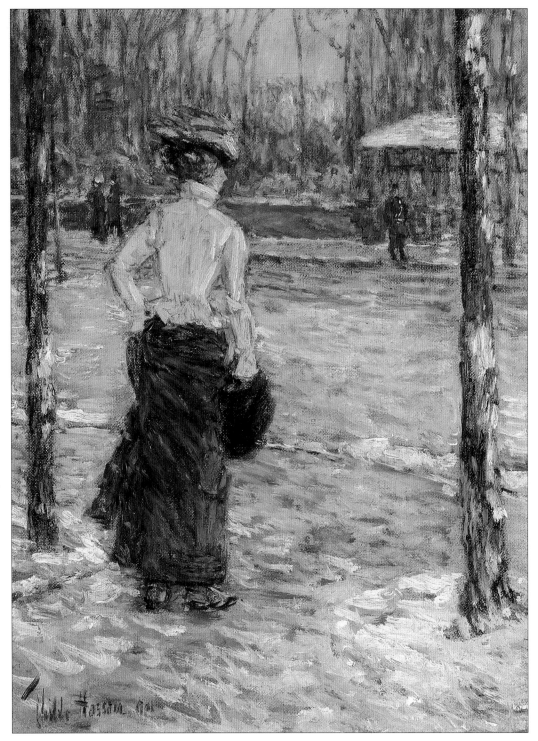

Plate 20

Childe Hassam

Winter, Central Park, 1901
Oil on canvas
16½ x 12⅜ in. (41.1 x 31.4 cm)
Private collection

Plate 21

Childe Hassam

The Southwest Wind, 1905
Oil on canvas
25 x 30 in. (63.5 x 76.2 cm)
Theodore T. and Mary G. Ellis Collection, 1940.67

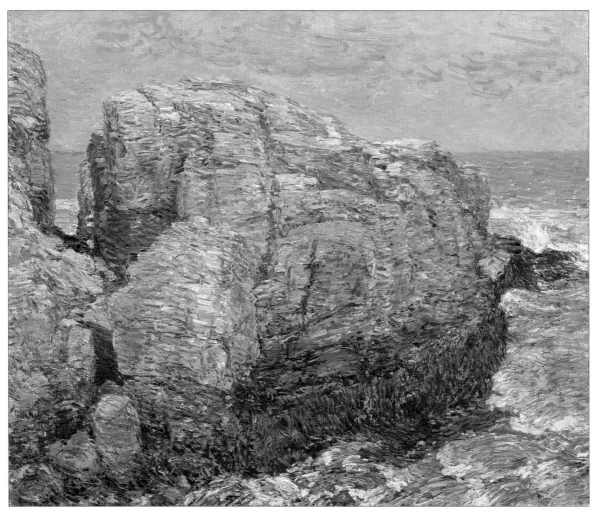

Plate 22

Childe Hassam

Sylph's Rock, Appledore, 1907
Oil on canvas
25 x 30 in. (63.5 x 76.2 cm)
Gift of Charlotte E. W. Buffington in memory
 of her husband, 1908.5

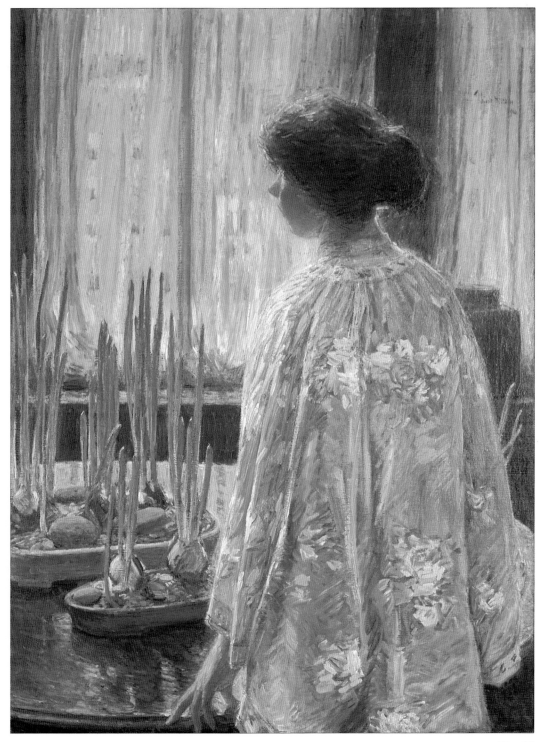

Plate 23

Childe Hassam

The Table Garden, 1910
Oil on canvas
39½ x 30 in. (100.3 x 76.2 cm)
Mitchell Museum at Cedarhurst,
 Mount Vernon, Illinois
Gift of John R. and Eleanor R. Mitchell

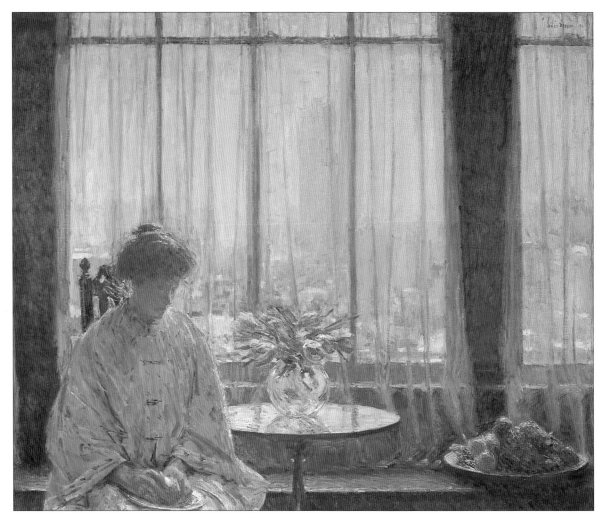

Plate 24

Childe Hassam

The Breakfast Room, Winter Morning, 1911
Oil on canvas
25⅛ x 30⅛ in. (63.8 x 76.5 cm)
Museum purchase, 1911.29

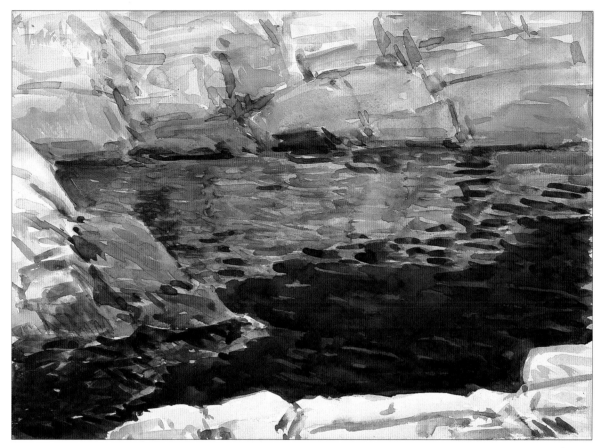

Plate 25

Childe Hassam

Looking into Beryl Pool, 1912
Watercolor on off-white wove paper
10⅞ x 15¼ in. (27.6 x 38.8 cm)
Bequest of Charlotte E. W. Buffington, 1935.53

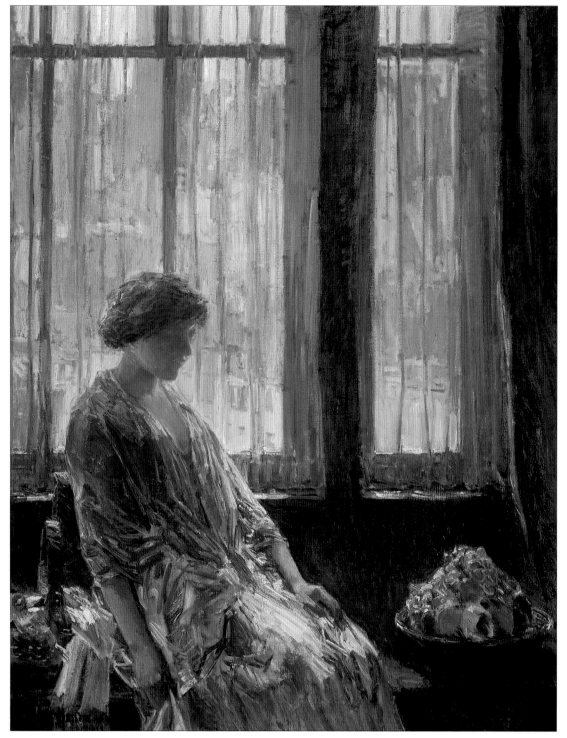

Plate 26

Childe Hassam

The New York Window, 1912
Oil on canvas
45½ x 35 in. (115.6 x 88.9 cm)
In the Collection of the Corcoran Gallery of Art,
 Washington, D.C. Museum Purchase, Gallery Fund

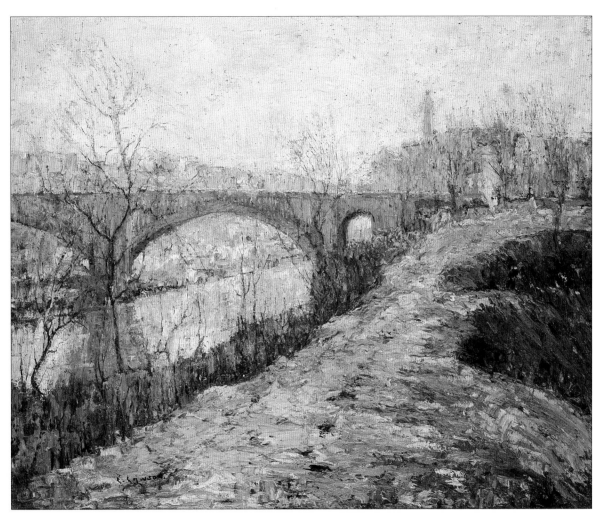

Plate 27

Ernest Lawson (1873-1939)

Washington Bridge, c. 1912
Oil on canvas
20⅛ x 24 in. (51.1 x 61 cm)
Private collection

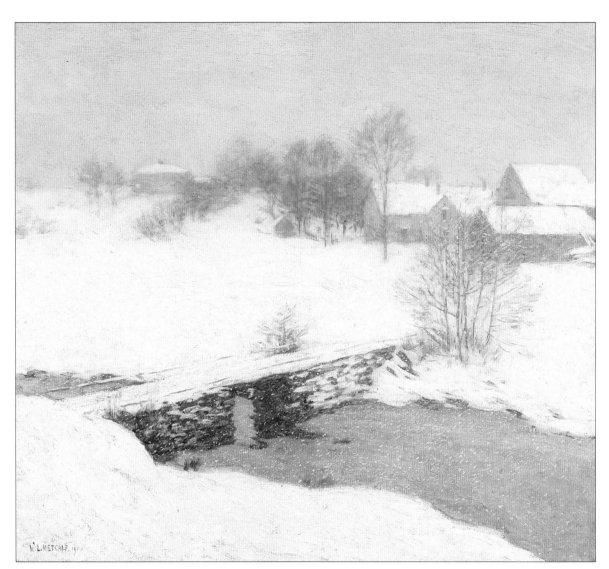

Plate 28

Willard LeRoy Metcalf (1858-1925)

The White Mantle, 1906
Oil on canvas
26 x 29 in. (66 x 73.7 cm)
Private collection

Plate 29

Willard LeRoy Metcalf

Prelude, 1909
Oil on canvas
35¹⁵⁄₁₆ x 39 in. (91.3 x 99.1 cm)
Museum purchase, 1910.1

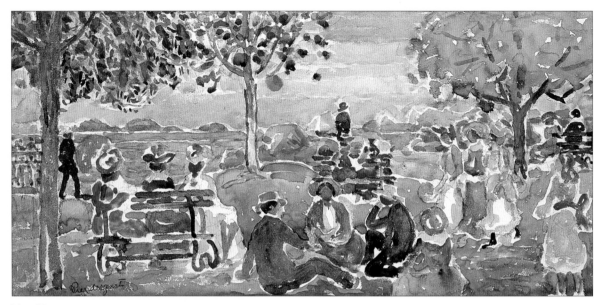

Plate 30

Maurice Prendergast (1859-1924)

Gloucester Park, c. 1920–23
Watercolor over charcoal and graphite
 on off-white wove paper
Image: 11⅛ x 22½ in. (28.3 x 57.2 cm)
Sheet: 14⅜ x 22½ in. (36.5 x 57.2 cm)
Museum purchase, 1941.38

John Singer Sargent (1856–1925)

Venetian Water Carriers, 1880–82
Oil on canvas
25⅜ x 27¹³⁄₁₆ in. (64.4 x 70.6 cm)
Museum purchase, 1911.30

JOHN SINGER SARGENT 71

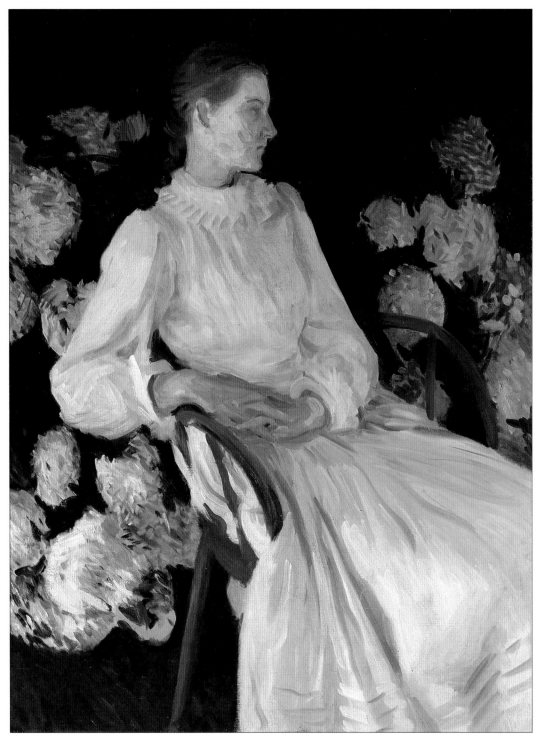

Plate 32

John Singer Sargent

Katherine Chase Pratt, 1890
Oil on canvas
40 x 30⅛ in. (101.6 x 76.5 cm)
Gift of William I. Clark, 1983.36

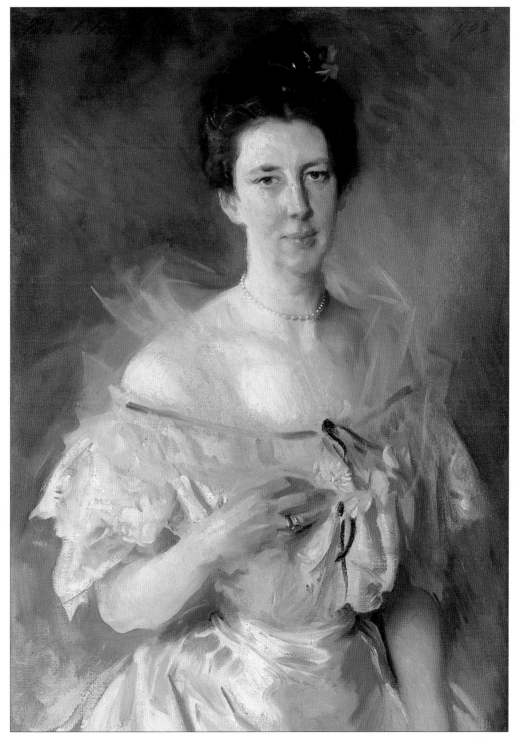

John Singer Sargent

Mrs. Gardiner Greene Hammond (Esther Fiske Hammond), 1903
Oil on canvas
35 x 25⅛ in. (88.9 x 63.8 cm)
Gift of Elizabeth Mifflin Hammond, 1961.36

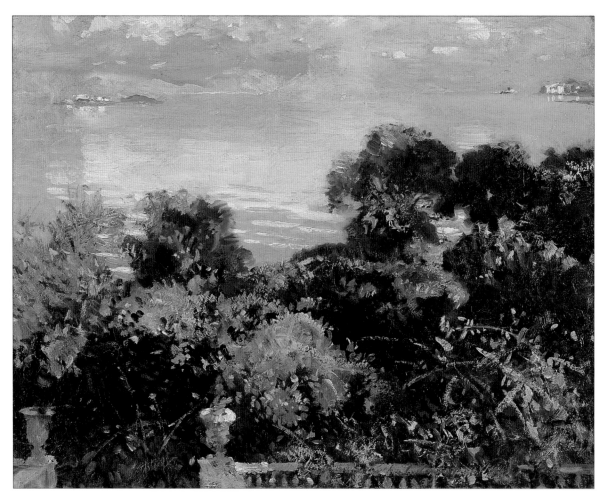

Plate 34

John Singer Sargent

Oranges at Corfu, c. 1909
Oil on canvas
22 x 28 in. (55.9 x 71.1 cm)
Theodore T. and Mary G. Ellis Collection, 1940.99

Plate 35

John Singer Sargent

Muddy Alligators, 1917
Watercolor over graphite on off-white wove paper
13⁹/₁₆ x 20⅞ in. (34.4 x 53 cm)
Sustaining Membership Fund, 1917.86

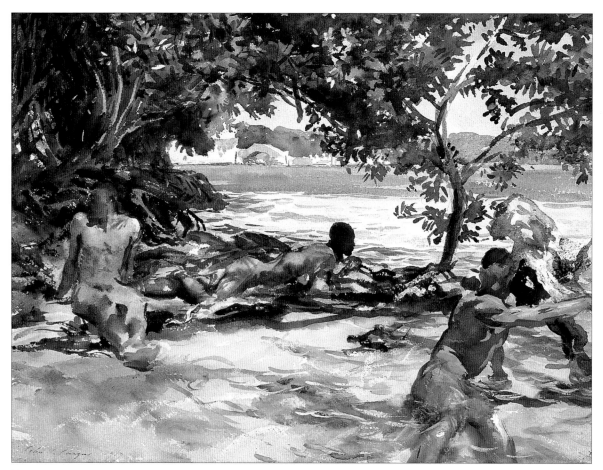

Plate 36

John Singer Sargent

The Bathers, 1917
Watercolor and gouache over graphite
on off-white wove paper
15¾ x 20⅞ in. (40.1 x 53 cm)
Sustaining Membership Fund, 1917.91

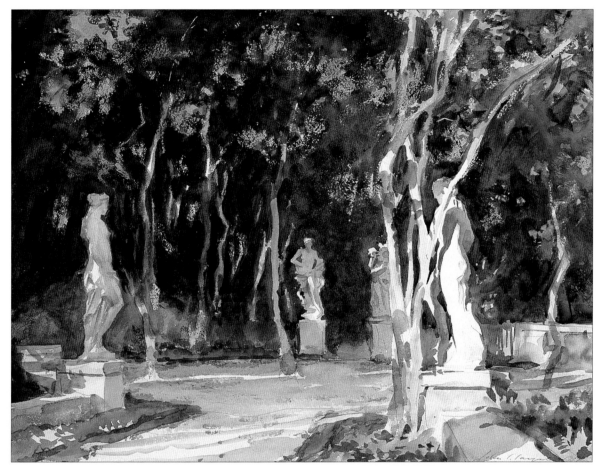

Plate 37

John Singer Sargent

Shady Paths, Vizcaya, 1917
Watercolor over graphite on cream wove paper
15⅝ x 21 in. (39.7 x 53.3 cm)
Sustaining Membership Fund, 1917.88

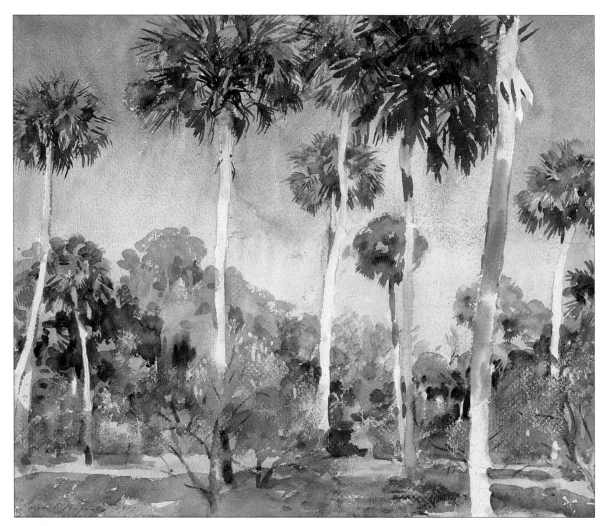

Plate 38

John Singer Sargent

Palms, 1917
Watercolor over graphite on off-white wove paper
15¾ x 20⅞ in. (40.1 x 53 cm)
Sustaining Membership Fund, 1917.89

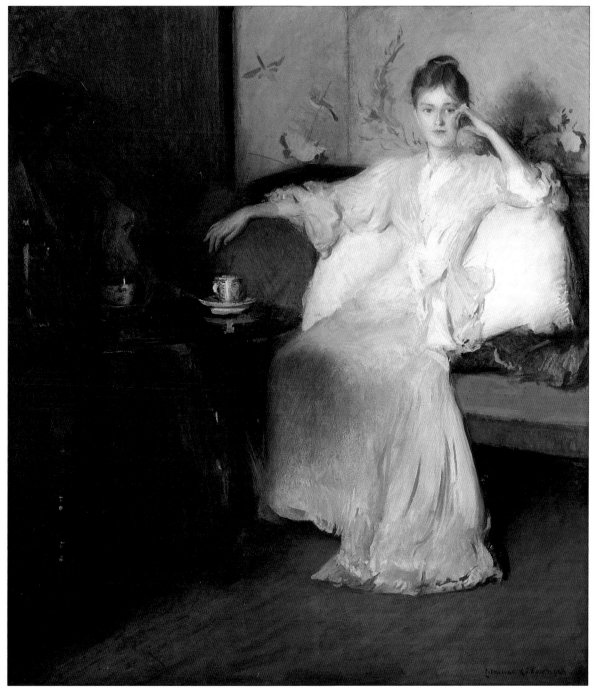

Plate 39

Edmund C. Tarbell (1862–1938)

Arrangement in Pink and Gray (Afternoon Tea), c. 1894
Oil on canvas
44⅞ x 43¹¹⁄₁₆ in. (114 x 111 cm)
Anonymous gift of 25-percent ownership, 1995.73

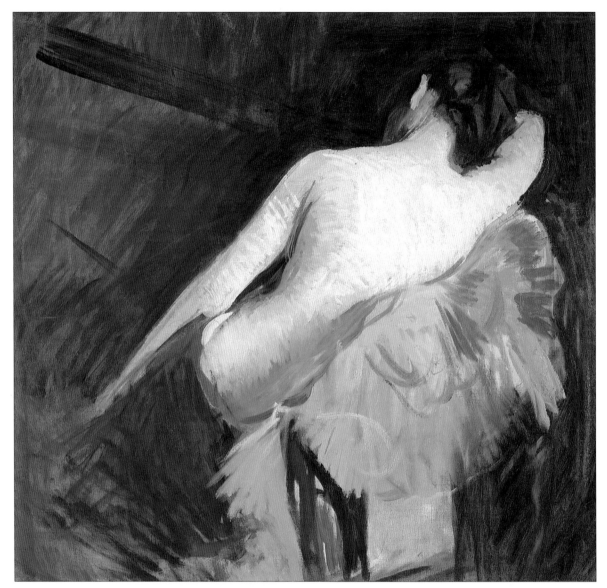

Plate 40

Edmund C. Tarbell

Study for *The Venetian Blind*, 1898
Oil on canvas
24 x 25½ in. (60.9 x 64.8 cm)
Eliza S. Paine Fund, 1996.75

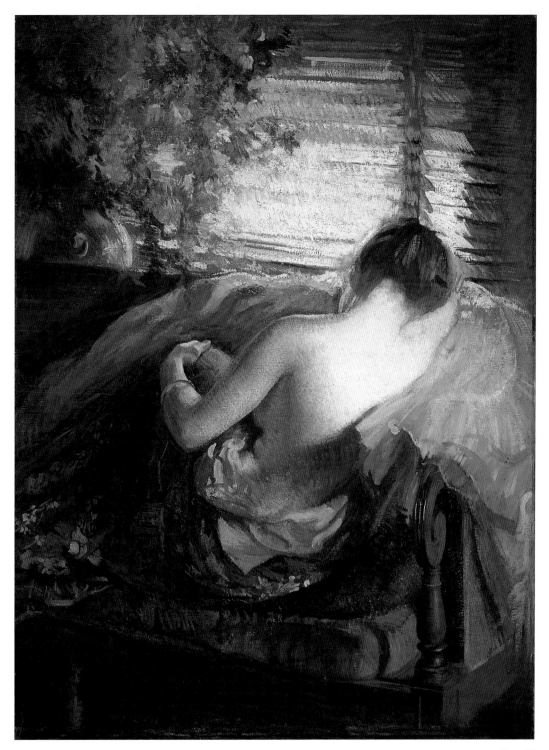

<div align="right">Plate 41</div>

Edmund C. Tarbell

The Venetian Blind, 1898
Oil on canvas
51⅞ x 38⅜ in. (131.8 x 97.5 cm)
Museum purchase, 1904.63

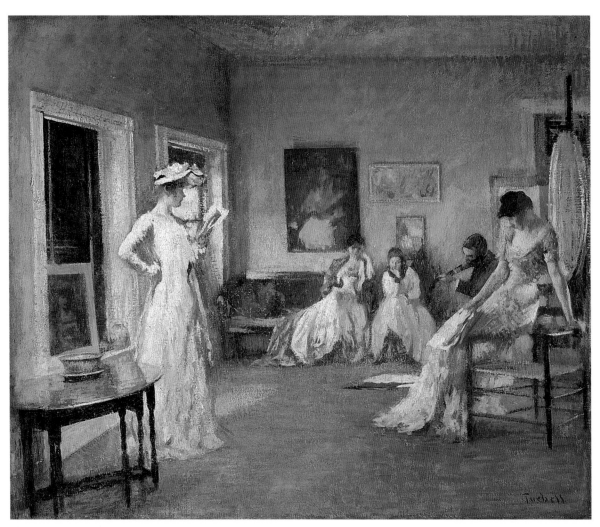

Plate 42

Edmund C. Tarbell (1862-1938)

Rehearsal in the Studio, c. 1904
Oil on canvas
25 x 30 in. (63.5 x 76.2 cm)
Gift of Mr. and Mrs. Henry H. Sherman, 1922.200

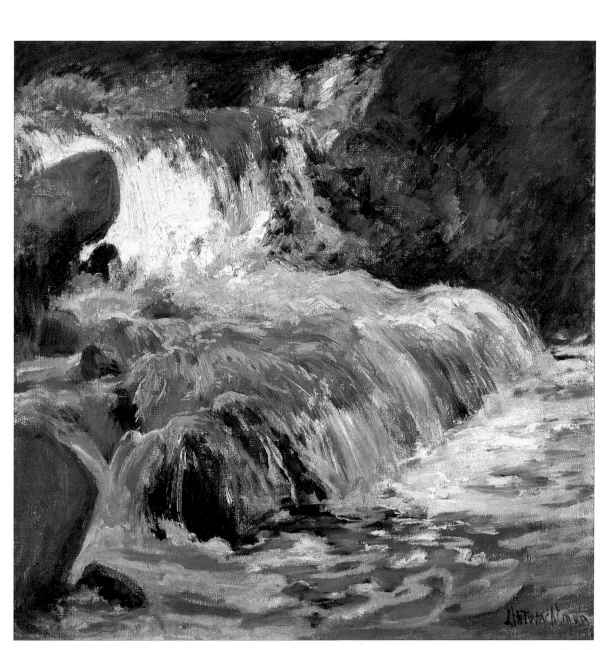

Plate 43

John Henry Twachtman (1853-1902)

The Waterfall, 1890s
Oil on canvas
30 x 30⅛ in. (76.2 x 76.5 cm)
Museum purchase, 1907.91

Plate 44

<div align="right">

John Henry Twachtman

The Rapids, Yellowstone, 1890s
Oil on canvas
30 x 30⅛ in. (76.2 x 76.5 cm)
Museum purchase, 1917.13

</div>

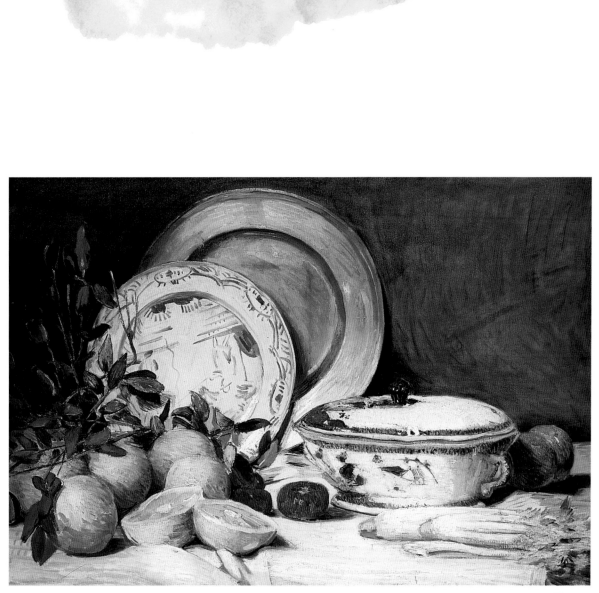

Plate 45

J. Alden Weir (1852-1919)

Still Life, c. 1902–05
Oil on canvas
24¾ x 36⅛ in. (62.9 x 91.8 cm)
Indianapolis Museum of Art
James E. Roberts Fund

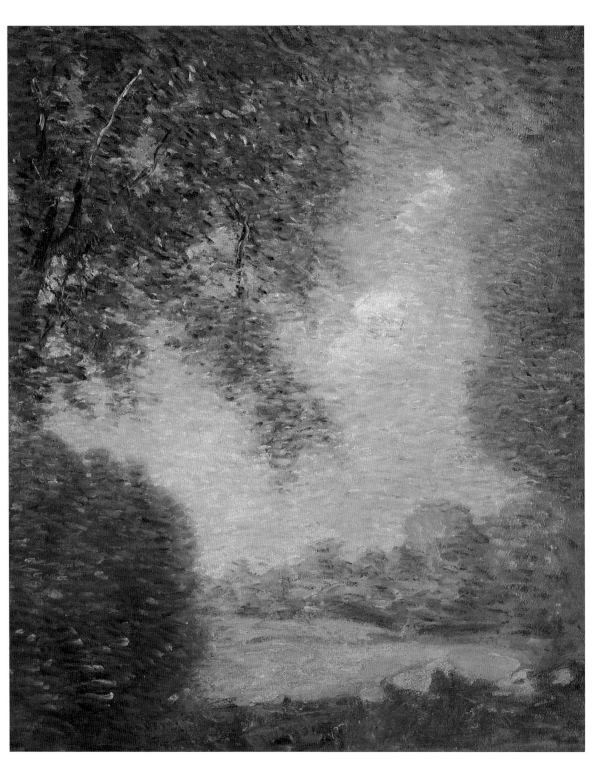

Plate 46

J. Alden Weir

Overhanging Trees, c. 1909
Oil on canvas
24 x 20 in. (61 x 50.8 cm)
Private collection

<div align="right">Plate 47</div>

James Abbott McNeill Whistler (1834–1903)

Sketch for *Rose and Silver: La Princesse du Pays de la Porcelaine*, 1863–64
Oil on hardboard
24⅛ x 13³⁄₁₆ in. (61.3 x 33.5 cm)
Theodore T. and Mary G. Ellis Collection, 1940.56

Selected Bibliography

Atkinson, D. Scott et al. *William Merritt Chase: Summers at Shinnecock, 1891–1902.* exh. cat. Washington, D.C.: National Gallery of Art, 1987.

Banta, Martha. *Imaging American Women: Idea and Ideals in Cultural History.* New York: Columbia University Press, 1987.

Bedford, Faith Andrews. *Frank W. Benson: American Impressionist.* New York: Rizzoli, 1994.

Bodnar, John. *The Transplanted: A History of Immigrants in Urban America.* Bloomington: Indiana University Press, 1985.

Boyle, Richard J. *John Twachtman.* New York: Watson-Guptill, 1979.

Buckley, Laurene. *Joseph DeCamp: Master Painter of the Boston School.* Munich and New York: Prestel-Verlag, 1995.

Burke, Doreen Bolger. *J. Alden Weir: An American Impressionist.* Newark: University of Delaware Press; New York, London, and Toronto: Cornwall Books, 1983.

Carr, Carolyn Kinder et al. *Revisiting the White City: American Art at the 1893 World's Fair.* exh. cat. Washington, D.C.: National Museum of American Art and National Portrait Gallery, Smithsonian Institution, 1993.

Clark, Carol et al. *Maurice Brazil Prendergast; Charles Prendergast: A Catalogue Raisonné.* Williamstown, Mass.: Williams College Museum of Art; Munich: Prestel-Verlag, 1990.

Curry, David Park. *Childe Hassam: An Island Garden Revisited.* exh. cat. New York and London: Denver Art Museum in association with W. W. Norton, 1990.

De Veer, Elizabeth, and Richard J. Boyle. *Sunlight and Shadow: The Life and Art of Willard L. Metcalf.* New York: Abbeville Press, 1987.

DiMaggio, Paul. "Cultural Entrepreneurship in Nineteenth-Century Boston: The Creation of an Organizational Base for High Culture in America." In Richard Collins et al, eds. *Media, Culture, and Society: A Critical Reader.* London and Beverly Hills: Sage Publications, 1986. 194–211.

Eisenman, Stephen F. et al. *Nineteenth Century Art: A Critical History.* London and New York: Thames and Hudson, 1994.

Fairbrother, Trevor J. et al. *The Bostonians: Painters of an Elegant Age, 1870–1930.* exh. cat. Boston: Museum of Fine Arts, 1986.

Fink, Lois Marie. *American Art at the Nineteenth-Century Paris Salons.* Washington, D.C.: National Museum of American Art, Smithsonian Institution; Cambridge, England: Cambridge University Press, 1990.

Gerdts, William H. *American Impressionism.* New York: Abbeville Press, 1984.

_____ et al. *Ten American Painters.* exh. cat. New York: Spanierman Gallery, 1990.

Hiesinger, Ulrich W. *Impressionism in America: The Ten American Painters.* Munich: Prestel-Verlag, 1991.

_____. *Childe Hassam: American Impressionist.* exh. cat. Munich and New York: Prestel-Verlag, 1994.

Herbert, Robert L. *Impressionism: Art, Leisure, and Parisian Society.* New Haven, Conn., and London: Yale University Press, 1988.

Hosley, William. *The Japan Idea: Art and Life in Victorian America.* exh. cat. Hartford, Conn.: Wadsworth Atheneum, 1990.

Kasson, John F. *Rudeness and Civility: Manners in Nineteenth-Century Urban America.* New York: Hill and Wang, 1990.

Lears, T. J. Jackson. *No Place of Grace: Antimodernism and the Transformation of American Culture, 1880–1920.* New York: Pantheon, 1981.

Levine, Lawrence W. *Highbrow/Lowbrow: The Emergence of Cultural Hierarchy in America.* Cambridge, Mass., and London: Harvard University Press, 1988.

Matthews, Glenna. *The Rise of Public Woman: Woman's Power and Woman's Place in the United States, 1630–1970.* New York and Oxford: Oxford University Press, 1992.

Mathews, Nancy Mowll. *Mary Cassatt.* New York: Harry N. Abrams in association with the National Museum of American Art, Smithsonian Institution, 1987.

Pisano, Ronald G. *William Merritt Chase.* New York: Watson-Guptill, 1979.

Rosenzweig, Roy. *Eight Hours for What We Will: Workers and Leisure in an Industrial City, 1870–1920.* Cambridge, England, and New York: Cambridge University Press, 1983.

Smith-Rosenberg, Carroll. *Disorderly Conduct: Visions of Gender in Victorian America.* New York and Oxford, England: Oxford University Press, 1985.

Spanierman, Ira et al. *Frank W. Benson: The Impressionist Years.* exh. cat. New York: Spanierman Gallery, 1988.

Spencer, Harold et al. *Connecticut and American Impressionism.* Storrs: William Benton Museum of Art, University of Connecticut, 1980.

Strickler, Susan E. et al. *American Traditions in Watercolor: The Worcester Art Museum Collection.* exh. cat. New York: Abbeville Press for the Worcester Art Museum, 1987.

Trachtenberg, Alan. *The Incorporation of America: Culture and Society in the Gilded Age.* New York: Hill and Wang, 1982.

Vatter, Harold G. *The Drive to Industrial Maturity: The United States Economy, 1860–1914.* Westport, Conn.: Greenwood Press, 1975.

Wallach, Alan. "On the Problem of Forming a National Art Collection in the United States: William Wilson Corcoran's Failed National Gallery." In Gwendolyn Wright, ed. *The Formation of National Collections of Art and Archaeology. Studies in the History of Art 47.* Center for Advanced Study in the Visual Arts, Symposium Papers XXVII. Washington, D.C.: National Gallery of Art, 1996. 113–25.

Weinberg, H. Barbara. *The Lure of Paris: Nineteenth-Century American Painters and Their French Teachers.* New York: Abbeville Press, 1991.

_____ et al. *American Impressionism and Realism: The Painting of Modern Life, 1885–1915.* exh. cat. New York: The Metropolitan Museum of Art, 1994.